VICTORIAN STUDIO PHOTOGRAPHS

VICTORIAN STUDIO PHOTOGRAPHS

from the collections of Studio Bassano
and Elliott & Fry, London

by

Bevis Hillier

with contributions by
Brian Coe, Russell Ash and Helen Varley

DAVID R. GODINE, BOSTON

David R. Godine, Publisher
Boston, Massachusetts

LCC No: 75–16549
Hardcover ISBN 0 87923 164 5
Softcover ISBN 0 87923 173 4

First published in the USA 1976

Victorian Studio Photographs © Ash & Grant 1975
Photographic plates pp 33–141 © Studio Bassano Ltd 1975

Printed in Great Britain by
Westerham Press, Westerham, Kent

Contents

Victorian Studio Photographs

In a passage of historical nostalgia more than normally maudlin, the late G. M. Young suggested that the Victorians, in their photographs, look far more noble than the moderns. Their domed craniums, their beetling brows, their mouths set in expressions of invincible rectitude, their chins jutting with resolution beneath forests of beard and whisker, seemed to him the icons of a civilization grander and more generous than ours. No wonder he hated Lytton Strachey, who guyed Young's heroes in *Eminent Victorians*. G. M. Young was a connoisseur of Victorians. He even arranged them in a league table of importance. Who, he wondered, was the Greatest Victorian? George Eliot, with her 'gnomic wisdom', had much to commend her. Tennyson was a strong candidate, both as a great poet and as a man 'profoundly in sympathy with the chief preoccupations of his time'. Something could be said for Matthew Arnold, more for Ruskin – 'and on Ruskin's claims one must pause carefully and long'. But Ruskin is finally dismissed as too child-like and incoherent to be typical of an age which loved solidity and efficiency, qualities in which Gladstone scores high marks. Carlyle? Browning? Newman? Young finally funks the choice of the Greatest Victorian and instead awards a skimpy laurel to Walter Bagehot – banker, shipowner, economist, editor, literary critic and constitutional historian – as 'the most Victorian of the Victorians'. Nevertheless one gets the impression that there are very few, even at the bottom of his league table, that Young would not have placed above any of his own contemporaries.

The Victorians themselves did not necessarily share Young's view of their inherent nobility. John Addington Symonds – who was personally more interested in noble bodies than noble characters – postulated the eventual arrival of a more acceptable generation:

> These things shall be! A loftier race
> Than e'er the world hath known shall rise,
> With flame of freedom in their souls,
> And light of knowledge in their eyes.

The Victorians, after all, believed in Progress, which included the infinite perfectibility of the human race; and even Macaulay, in the third chapter of his *History of England*, conceded that 'We too shall, in our turn, be outstripped'.

It is arguable that the First World War deprived us of the 'loftier race' – those who would have been the luminaries and Grand Old Men of today. But it can also be argued that the images we have of

the great Victorians are all set-pieces, studio portraits posed with all the artifice of cunningly disposed lighting; while the images of our modern statesmen, writers and scientists are so often Press snapshots: the instant cruelty of the intrusive telescopic lens at moments of stress, emotion or dishevelled informality. The candid camera is not necessarily the truest: as a character observes in Barrie's *The Admirable Crichton*, the man who begins a sentence, 'To be perfectly frank with you . . .' is usually about to tell a lie.

The Press photographers are the natural heirs of the journalistic draughtsmen sent out to make quick on-the-spot sketches which would later be laboriously engraved. (Constantin Guys covered the Crimean War in this way for the *Illustrated London News* and in America Frederic Remington, better known for his paintings and bronzes of cowboys, was an illustrator for Hearst newspapers. The story goes that he was sent by Hearst to cover the Cuban War. On arriving in Cuba he cabled Hearst, 'Here I am, but there's no war'. Hearst cabled back: 'Stay where you are and I'll see to the war'.) The studio photographers, by contrast, were the natural heirs of the old professional portrait painters and miniaturists. Not merely natural heirs, but actual heirs. The descent (I use the word in a purely

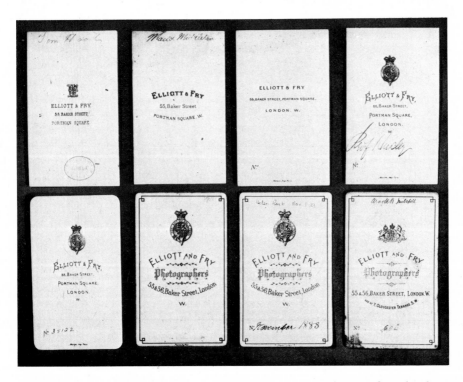

A selection of backs of Elliott & Fry *cartes de visite* showing their development from the 1870s to 1890s. Note especially the increasingly elaborate decoration, royal insignia and the introduction of rounded corners

genealogical, not pejorative, sense) is shown most clearly on the backs of studio photographs, which are usually emblazoned with cartouches, florid lettering, armorial bearings or hyperbolic tributes from the Press. In fact, one could make an attractive and instructive collection of photographs for the sake of their backs, rather than their fronts, which all too often show redoubtable old miseries glaring into the lens from above crinolines or below poke bonnets. The earliest example that has passed through my hands bears a simple yellow label on the reverse: 'MR. CAVE, Calotype Artist, 17 Portman Place (One door from New Church Street), EDGWARE ROAD, LONDON.' The calotype (an early photographic process) shows a schoolboy in a cap with a small peak and a flamboyant necktie, holding a book and looking sorry for himself. The present owner very properly displays it face to the wall.

In these early days, studio photography was of course a devastating rival to painting, especially to the painting of miniatures. Some of the miniaturists defected to photography, but they were careful to point out that they were still artists for a' that. Some of the earliest photographs have demure little labels on the back: 'R. R. Taylor, Artist, Westbury, Wilts.'; 'James Briddon, Photographic Artist, The Esplanade, Ventnor, Isle of Wight'; and 'Fisher, Miniature Painter and Photographer, No. 1 Victoria Place, CLIFTON'. A rhyme of this period ran:

> A limner, by Photography
> Dead beat in competition,
> Thus grumbled:
> 'No, it is opposed, Art sees Trade's opposition!'

(The last line of this silly jingle is a palindrome, reading the same backwards as forwards, like 'Madam, I'm Adam', 'Stiff, O Dairy-man, in a myriad of fits', or 'Now stop, Major-General, are Negro jam pots won?')

The painters themselves had a hard battle, in the 18th century, to establish the acceptability and dignity of their profession. As an illustration of the treatment of artists by their proud patrons in the early 18th century, Basil Williams, in *The Whig Supremacy*, tells the story of the sixth Duke of Somerset and his namesake, James Seymour, whose sporting pictures now command high prices in the sale-room. The Duke once addressed him in condescending banter as 'cousin Seymour', to which Seymour presumptuously replied that they were no doubt of the same race. For this impertinence, Williams records, he was summarily packed off, but the Duke, unable to find a horse painter, recalled him to paint his stud. 'My lord,' Seymour answered, 'I will now prove I am of your Grace's family, for I won't come.'

Grandiose 'history' paintings and the foundation of the Royal Academy of Art in 1768 were intended to improve the artist's social

status. The process continued through the 19th century with the knighting of Millais, Burne-Jones, Poynter and Alma-Tadema and the ennobling of Lord Leighton – the first English artist to be made a peer; though in the early years of the century it was still thought *infra dig* for Sir Francis Grant, a huntin' country baronet, to mess with oil paints. The attitude was tenacious. In 1891, Henry Stacy Marks, R.A. (a noted bird-painter, who designed the frieze around the Royal Albert Hall in London) told an interviewer from the *Strand Magazine*:

> I had a very nasty knock given me one morning at the Zoo. I must not mention in what house it was, as the old keeper is there still. I had been sketching there one Saturday, and was just packing up my various things thinking of going, when he turned to me and said, 'You are not going to wait to do any more then, sir?' I said, 'No, I am going to town this afternoon, just for a little trip, you know!' 'Oh yes, sir, of course. I have heard as most tradespeople like to take their half-holiday on Saturday.'

And as late as the 1920s a *Punch* cartoon could still make capital from the artist's status:

> *Maid:* There's someone to see you, madam.
> *Lady of the house:* Is he a gentleman?
> *Maid:* No, madam, it's only an artist.

The photographers were perhaps less concerned than the painters about their personal status in society, but they were just as concerned to establish the dignity of their art – particularly, to establish it as something more than legerdemain with mechanical apparatus and chemicals – as an art form with its own muses, skill and inspiration. As late as 1951, however, Sir Cecil Beaton could still write, in his *Photobiography*,

> Photographers, ranked as simple technicians, less 'artistic' even than the water-colour-painting governess with her sketch pad and her tussore parasol, came to suffer from an inferiority complex . . . In England . . . the 'black art' is still regarded with a certain distrust, and a photographer is believed by many to be a sort of otherwise un-employable half-wit whose existence passes clicking away from under a black cloth at something in front of a white cloth.

The painters glorified their art with fables: for example, in 1776 David Allan portrayed a popular neo-classical idea of the invention of painting – the Corinthian potter's daughter who drew her lover's profile by tracing his shadow on the wall. The painter's muse was usually represented as a buxom airborne woman dispensing inspiration from posy basket or cornucopia. The allegorization of art reached its nadir in the frontispiece of M. Hattenberger's *Collection de Dessins*, dedicated to Alexander I of Russia and published in St Petersburg in 1805. This engraving shows beams of light shining

from the left nipple of a lusty helmeted woman attended by a stork, projecting a portrait of a man in military uniform (Alexander I?) on to a board, doubtless by some miraculous early photographic technique: the caption is 'La véritable reconnoissance est gravé dans le coeur'. Yet even this can scarcely compare, in grotesque bathos, with the Muse of Photography on the cover of *Broader Britain*, a collection of photographs of lands of the British Empire; or with the winged cherub removing the lens-cap of a plate camera on the cover of the mildly risqué French book, *Le Panorama : Salon Le Nu.*

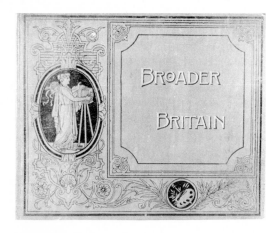

With photographers striving for respectability through the use of classical motifs, muses and cherubs were frequently associated with the novel art.

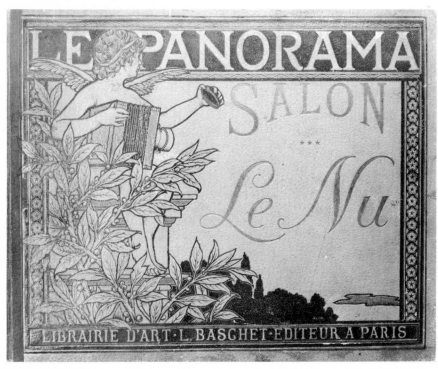

These attempts to invest the art of photography with a spurious dignity might seem clownish; but the campaign was succeeding. By 1871 it was succeeding so well that the subject set for the Chancellor's Prize for Latin Verse at Oxford University was *Photography* ('Sol Pictor'). The undergraduate who won it was Francis Paget, a future Bishop of Oxford.

In their quest for respectability, the photographers followed the example of the painters. The rooms where they conducted their work were 'studios'; eventually a Royal Photographic Society was founded, and photographers who qualified for membership were proud to use the initials F.R.P.S. after their name. Richard N. Speaight, a well-known portrait-photographer of the late Victorian and Edwardian periods, whose *Memoirs of a Court Photographer*, published in 1926, is one of the few books of reminiscence by a professional studio photographer, wrote:

> It has always been my contention that you cannot be a professional photographer unless you are also an artist. I painted a number of pictures – I don't say they were much good – but at least I learnt all about anatomy . . . Similarly, I have never failed to take any opportunity to make a tour of the principal art galleries of Europe to refresh my memory and to borrow ideas from the works of the old masters. I shall never forget my admiration for, nor would I care to say how often I have benefited by, the wonderful grouping of the 'Last Supper'. In particular the arrangement of the hands – always such a problem – has impressed me and guided me many times since.

When a Victorian postcard was produced showing a small boy in Fauntleroy costume photographing his sister with a plate camera, it

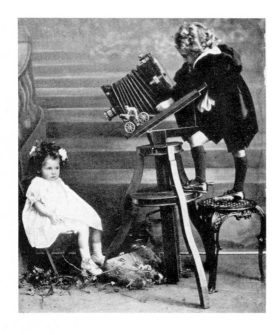

The new profession of studio photography became the object of sentimental satire

was the equivalent of Dyce's oil painting done in 1867 of the child Titian (*Titian's First Essay in Colour*).

With such pretensions, photography, like any profession trying to aggrandize itself, attracted satire. The most delightful example of this that I know is in J. Thomson's *Public and Private Life of Animals*, published in 1876 – five years after Francis Paget's prize poem. Thomson invents Topaz, a Brazilian monkey who comes to Europe and studies portrait painting. Realizing that he will never make the grade as a painter, Topaz steals a purse and with the contents buys a 'photographic camera': significantly, Thomson compares this action to that of a musician who gives up his piano and flute and buys a barrel-organ. Returning to Brazil, he pitches his camp in a vast forest glade, and, 'aided by a black-faced Sapajo called Ebony', sets up 'an elegant hut of branches beneath an ample shade of banana leaves', placing above the door a signboard: 'Topaz, painter after the Parisian fashion' and inscribing on the door itself, 'Entrance to the Studio'. The obvious implication is that the photographer is a failed painter, aping (in this case, literally) the true artist. Both the text and illustrations of Thomson's fantasy give a good idea of studio photography in the late Victorian period. Topaz's first client is a boar, 'a trifle foppish and very much in love', who wants a portrait as a gift for his betrothed:

> Entering the studio he paid double the usual price, as this Boar was the most liberal member of his government. He then seated himself solidly down in his appointed place where his steadiness and unconcern rendered him a capital subject for the camera. Topaz on his part exercised all his skill in posing, lighting and photographing. The portrait was a perfect gem, his lordship was delighted. The little image seemed to reduce his bulk in every way, while the silvery grey of the metallic plate replaced with advantage the sombre monotony of his dark coat. It was a most agreeable surprise, and fast as his bulk and dignity would allow him, he hastened to present the picture to his idol. The loved one was in rapture, and by a peculiar feminine instinct she first suspended the miniature round her neck, then, as instinctively, called together her relatives and friends to form an admiring circle around her lover's portrait. Thanks to her enthusiasm, before the day was over, all the animal inhabitants for miles around were appraised of the marvellous talent of Topaz, who soon became quite the rage. His cabin was visited at all hours of the day, the camera was never for a moment idle. As for Sapajo he had more than enough to do in preparing the plates for every new comer. With the exception of the apes, there was not a single creature in earth, air or water, who had not sat for a likeness to the famous Topaz.

One of the illustrations in Thomson's book shows the photographer at work, his artist's palette and mahl-stick symbolically strung up in a palm tree. His assistant is pouring chemicals onto a plate in a tub, while a bird sitter in a tall hat is posing, his long neck clamped fast in one of the neck-clamps which were necessary to studio photography in the days before exposure times were reduced.

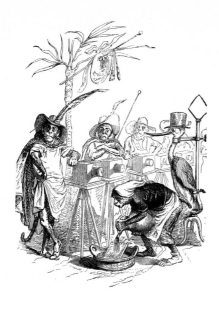

Topaz, the monkey-turned-photographer of J. Thomson's story, poses as the master of a grand emporium

To return to Topaz, he touched up his portraits to suit the taste and vanity of his customers. In this, it must be owned, he did not always succeed. Some of his clients were all beak, and had no focus in them; others could not sit steady for a second, the result was, they figured on the plate with two heads, and a group of hands like Vishnu, the heathen god. They jerked their tails at some fatal moment, rendering them invisible in the photograph. Pelicans thought their beaks too long. Cockatoos complained of the shortness of theirs. Goats said their beards had been tampered with. Boars held that their eyes were too piercing. Squirrels wanted action. Chameleons changed colour; while the donkey thought his portrait incomplete without the sound of his mellifluous voice. Most comical of all – the owl, who had shut his eyes to the sun, maintained that he was represented stone blind, thus destroying his chief attraction.

Lewis Carroll's parody of Longfellow's *Hiawatha*, which he called 'Hiawatha's Photographing', also concerns some sitters who were not best pleased with the results:

From his shoulder Hiawatha
Took the camera of rosewood,
Made of sliding, folding rosewood;
Neatly put it all together.
In its case it lay compactly,
Folded into nearly nothing;
But he opened out the hinges,
Pushed and pulled the joints and hinges,
Till it looked all squares and oblongs,
Like a complicated figure
In the Second Book of Euclid.
 This he perched upon a tripod –
Crouched beneath its dusky cover –
Stretched his hand, enforcing silence –

Said, 'Be motionless, I beg you!'
Mystic, awful was the process.
 All the family in order
Sat before him for their pictures:
Each in turn, as he was taken,
Volunteered his own suggestions,
His ingenious suggestions.
 First the Governor, the Father:
He suggested velvet curtains
Looped about a massy pillar;
And the corner of a table,
Of a rosewood dining table.
He would hold a scroll of something
Hold it firmly in his left-hand;
He would keep his right-hand buried
(Like Napoleon) in his waistcoat;
He would contemplate the distance
With a look of pensive meaning,
As of ducks that die in tempests.
Grand, heroic was the notion:
Yet the picture failed entirely:
Failed, because he moved a little,
Moved because he couldn't help it.

Then follow the simpering wife and the son, who is an Aesthete:

He suggested curves of beauty,
Curves pervading all his figure...
He had learnt it all from Ruskin,
(Author of 'The Stones of Venice',
'Seven Lamps of Architecture',
'Modern Painters' and some others);
And perhaps he had not fully
Understood his author's meaning.

Then the eldest daughter, with her look of 'passive beauty' and finally the youngest son, who is shown in an illustration by A. B. Frost drawn in 1881 in a ferocious neck-clamp. At last a group photograph is staged, which all the family detest:

Really any one would take us
For the most unpleasant people!

Hiawatha makes a hurried getaway.

Carroll no doubt knew all about disgruntled sitters, as he was himself, of course, an enthusiastic amateur photographer. The great Victorian amateurs, though they contributed so much to the art of photography, were a different breed from professionals such as Speaight or Elliott and Fry. They included that tyrannical old woman Julia Margaret Cameron, who hustled and harried such sitters as Tennyson in her Isle of Wight lair and dragooned her parlour-maid into posing as the Virgin Mary; David Wilkie Wynfield, who photographed Royal Academicians in fancy dress and was Mrs Cameron's tutor in photography; Judge George Giberne,

15

to whom we are indebted for photographs of Gerard Manley Hopkins at the age of 12, for he was the poet's uncle; and Sir Henry Thompson, artist, connoisseur, writer, traveller, social reformer, society host and physician (he operated on Napoleon III, who died soon afterwards) who, in 1891, at the age of 70, took up photography and found it 'an extremely interesting substitute for the practice of Art in colour'.

By the time Sir Henry conceived his whim for photography and, while staying in Falmouth 'with his usual impetuosity . . . telegraphed to London for a camera', professional portrait photography was a roaring business in the capital. Daguerre had announced his discovery of the earliest practical process of photography in 1839. The French Government, with exceptional generosity, had induced him to give the invention freely to the world (except England) in consideration of a pension for life. The photograph was made on a silvered copper plate; its great disadvantages were the long exposure required and the need to whiten the sitters' faces and place them in direct sunlight. In the same month as Daguerre published his process, William Henry Fox Talbot, of Lacock Abbey, Wiltshire, read a paper to the Royal Society on his calotype method, which was to produce pictures on paper instead of on a silvered copper plate. This too was a slow, laborious process. The earliest outstanding examples of the method in action were the work of D. O. Hill, R.S.A., and R. Adamson: the former an artist, the latter a photographer.

Between 1842 and about 1860 the daguerreotype method was adopted and practised with particular enthusiasm in the United States. Its use in England was limited to licensees of Daguerre, who had obtained a patent for his process in 1839. One of the pioneers of the process in England was J. E. Mayall, a studio photographer who worked in Regent Street, London. He was also one of the last daguerreotypists. His business, which later developed into one of the most popular in the country for naval and military photographs, was bought by Richard Speaight's firm in 1914. Both daguerreotypists and 'paper photographers' adhered undeviatingly at first to the traditions of the portrait painters, especially in the sense that their works were what would now be called 'one-offs'. Speaight wrote,

> There was no selling dozens of photographs in those early days. To have a portrait or a silhouette made had always been a serious and expensive matter, and so it was also considered a serious matter to go to the photographer. Probably most photographers performed the whole of the work themselves – at any rate, all except the purely mechanical parts. Photographers were few and, at the prices they charged, a few sitters were sufficient to make business pay; which accounts for the small number of early photographic portraits.

All this was changed in 1859 by the introduction by Disderi, photographer to the court of Napoleon III, of the *carte-de-visite*, originally intended to be used as a visiting card but later produced in

great numbers for friends' albums. The *cartes-de-visite* of the eminent, inserted in luxurious albums specially designed for them, replaced the embossed crests of the famous which had been collected in albums for similarly snobbish reasons in the early 19th century. Not even a modern public relations firm could have devised a more effective way of stimulating the market in photography. The grand professional studio photographers, including Elliott and Fry, were sniffy about the host of 'untrained' photographers which sprang up at this time to meet the new demand and Speaight wished that the same system prevailed in London as in Vienna, where photography was a protected profession which no-one who had not served an apprenticeship could join. Speaight was particularly scathing about the props favoured by these 'mushroom' photographers:

> From time to time it is true there were slight changes in the fashion of accessories employed, and after a time they became a little less obviously artificial. At first the pillar and the curtains were the universal features, and then came the verandah with balustrade overlooking the distant landscape. This was considered quite a proper setting for a lady in evening dress seated on a drawing-room chair and viewing the scene through the back of her head. The rustic stile, probably made with cork bark, was also very popular, especially in provincial studios. The lady's hat was always much in evidence, and the gentleman never appeared without a topper in his hand.

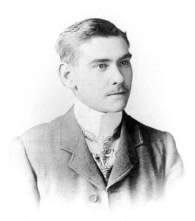

A cabinet photograph by F. W. Wood, a protégé of Elliott & Fry

By the end of the century every suburb had its photographic studio, where children would be frozen into tortured poses and asked to 'watch for the birdie', Billy in his sailor suit, Amy in her tam-o'-shanter, in front of an improbable painted seascape or garden. The big London studios' reaction to such competition was to establish satellites themselves – other photographers acting under their aegis, financed by them and mulcted of much of their profit by them, such as F. W. Wood ('Day and Electric Light Studios') who took this photograph of my maternal grandfather, in Pre-Raphaelite detail, and presumably in the first decade of the 20th century; he describes

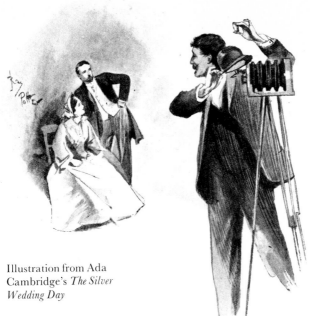

Illustration from Ada
Cambridge's *The Silver
Wedding Day*

himself on the back as 'F. W. Wood from Elliott & Fry. 22 Bishops
Rd., W. & 347 & 349 Edgware Rd., W.'

A short story by Ada Cambridge, 'The Silver Wedding-Day', pub-
lished in *The Woman at Home* magazine for March 1897, includes two
illustrations by Raymond Potter of the local Victorian studio photo-
grapher at work, one in the mid-Victorian period, the other in the
late-Victorian. Here is some of the accompanying narrative:

> 'Do you remember,' said Tom . . . 'how we had our likenesses taken
> in our wedding clothes?'
> 'And oh, such clothes!' I ejaculated. 'A flounced skirt over a
> crinoline, a spoon bonnet –'
> 'It was the image of you, my dear, and I wouldn't part with that
> picture for the world. I say, let's go and be done now. I'd like a
> memento of this day to look at when the golden wedding comes. Just
> as you are, in that nice tailor tweed – in your prime, Polly.'
> I told him it was nonsense, but he would have it. The people said
> they would be ready for us at 2.30, and when we had had an immense
> lunch, and were both looking red and puffy after it, we were photo-
> graphed together, like any pair of cheap trippers. I sitting in an attitude
> with my head screwed round, he standing over me with his hand on
> my shoulder. The result may now be seen in a handsome frame on his
> smoking-room mantelpiece. He thinks it beautiful.

To such local emporiums repaired so many Mr Pollys and Mr
Pooters and their families. But many of the famous people illustrated
in this book would have been solicited as clients by Elliott and Fry,
and in some cases photographed free, their patronage adding lustre
to the company's reputation. But if Society was making photography
respectable, photography was also helping to change Society.

Leonore Davidoff, in her recent penetrating analysis of Victorian Society, *The Best Circles*, wrote,

> In discussing the changes which led to greater visibility of upper-class life styles, the importance of photography is worth remarking. In the 1860s and 1870s the process was still being developed; it was an expensive business depending much on the patronage of wealthy enthusiasts. The practice of having Society events photographed caught on quickly and professional photographers followed the country house season as semi-upper servants, keeping records of influential gatherings complementary to the keeping of visitors' books. Later in the century, when photography was cheaper and quicker, the exploitation of 'professional' beauties and personalities in society by photographers accelerated the change to publicity.

Looking at the photographs in this book, I do not share G. M. Young's view that the Victorians were nobler-looking than our celebrities – the feeling that 'there were giants on the earth in those days'; it was merely that they were more *extreme* in their appearance. That Young himself could not settle on a Greatest Victorian, but had to content himself with a Most Victorian of the Victorians, goes some way towards confirming this. Whatever they were, whatever they did, they became – and looked – the quintessence of it. All of them were 'types'; some were archetypes. Their 'self-ness' or 'inscape', to use the word Gerard Hopkins minted, was of unprecedented intensity. None needed bidding to 'Be yourself': with most of them, it was a positive profession – hence the association of Victorians with 'eccentricity', which simply meant surrendering to their idiosyncrasies with a minimum of inhibition.

We have become used to thinking of the Victorians in terms of caricature – the verbal caricature of Lytton Strachey, the visual caricature of Max Beerbohm – but no-one made a better caricature of them than they did of themselves. Could one conceive an image of religious asceticism (combined with religious pomp and panoply) more outrageous than that of Cardinal Manning (page 115), the 'eagle' of Strachey's merciless pen-portrait? The Victorian memoirist G. W. E. Russell described him as having 'the irreducible minimum of flesh on his cheekbones . . . one imagined that like the Cardinal in *Lothair* he lived on dry biscuits and soda-water'. One can picture Manning piously mouthing that other Victorian palindrome: 'Desserts I desire not, so long no lost one rise distressed'. Could anyone look more like a musician than Liszt (page 47), more like a scientist than Professor Huxley (page 59), more like a melodramatic actor than the leonine Sir Henry Irving (page 39) or more like an actress and superb professional Beauty than Marie Tempest (page 37)? Gilbert's parody of the Aesthetic young man as Bunthorne in *Patience* is not a patch on Oscar Wilde's parody of him in Elliott and Fry's photograph (page 77).

There are, of course, exceptions. The pinched, mean look and astrakhan collar of Lord Shaftesbury (page 117) hardly suggest a

great philanthropist. Walter Pater, the discreet Oxford don who has claims to be the founder of the whole Aesthetic movement, the extoller of 'hard, gem-like flames' and the author of the memorable lines on the *Mona Lisa* beginning 'She is older than the rocks among which she sits', is revealed as a bald little man with a preposterous

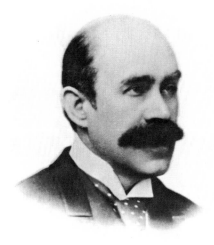

Walter Pater

moustache. But as William Gaunt has suggested, it may have been his appearance that led to his interest in ideal beauty:

> Gradually Pater became more inscrutable. It was about this time (1860) that he grew the moustache which completed the mask-like nature of his expressionless features. He was a 'Caliban of letters', was very sensitive about his looks, had been heard to say, 'I would give ten years of my life to be handsome'. Meetings were held among his friends to discuss the 'External Improvement of Pater'. Various suggestions were made. It was agreed that a moustache was the thing if anyone dared try to persuade him. To their surprise Pater took kindly to the idea and shortly there burgeoned on his upper lip that formidable luxuriance which provided him with a distinct character of his own. This sensitiveness about his own appearance helped to make him interested in ideal beauty.

Again, though one can see her as the type of the plain but clever New Woman of the age, one cannot quite see Ellen Thorneycroft Fowler (page 63) as a Romantic novelist, author of such bestsellers as *Concerning Isabel Carnaby, In Subjection, Her Ladyship's Conscience* and *The Wisdom of Folly*. I can imagine a cartoon by 'Max' entitled 'A Distraught Mr Elliott and a Rattled Mr Fry Attempting to make Miss Ellen Thorneycroft Fowler look like a Debutante of the Year, and very nearly Succeeding'.

We do actually have Max Beerbohm's caustic description of

Andrew Lang and it mentions the photographs which Lang loved to have taken of himself:

Andrew Lang

I had instantly recognised him from the photographs. He was leaning against an angle of the wall. One might almost have supposed that he had been placed there as an ornament, like a palm in a pot. From the buzzing human throng he seemed to be quite as detached as any palm in any pot. Slender and supereminent, he curved, he drooped, he,was a very beautiful thing in the room. And it was even more in colour than in form that he was so admirable. To think that Nature, and not some cunning handicraft of staining and bleaching, had produced these harmonious contrasts! The long nut-brown neck was not more sharply relieved by the white of the turned-down collar than was the nut-brown forehead by the silvery hair that caressed it, than were the nut-brown cheeks by the silvery vapour they had of whisker. And the moustache was jet-black, and jet-black were the eyebrows and eye-lashes. In such surroundings the whiteness of the eyeballs and the darkness of the brown eyes 'told' tremendously, of course. But in a spiritual sense the eyes told nothing at all. They shone, they flashed, but with no animation to belie the general look of inanimateness. Their lustre was as lovely and as meaningless as that of jewels. Nature had in some corner of the earth produced two large brown diamonds, of which she was very proud; and it had seemed to her that Andrew Lang's face would be the best of all possible settings for them. So there they were. I wondered whether, with things of such fabulous value ex-posed on his person, he went about armed, or unarmed but very heavily insured.

If a face could give away so much, could provide such ammunition for the character assassin, it was perhaps an asset for a politician to

have one which gave away nothing. This was the case with both John Morley (page 119), a cartoonist's nightmare with no distinctive feature on his face, and his long-term political ally Joseph Chamberlain (page 121), who at least had the grace to affect a cartoonable eyeglass and an orchid, but was otherwise so inscrutable that cartoonists often portrayed him as the Sphinx, as in this caricature by

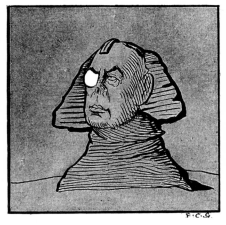

Joseph Chamberlain as the Sphinx

'The basilisk visage of Chamberlain'

Frank Carruthers Gould. Canon Henry Scott Holland (the contemporary and lifelong friend of Bishop Paget who wrote the Latin poem on *Photography*) wrote, with that masterful uncharity that the cloth can so often command, a brilliant description of this quality, or rather lack of quality, in Chamberlain's face:

> In that solemn hour, when we sat waiting in Westminster Abbey for the coming of Mr. Gladstone's funeral, shrouded in a natural sorrow, I found myself looking straight at Mr. Chamberlain during the long silence. And I set myself to the task of finding the signs in that face of the high qualities which the character behind it assuredly possessed . . . I could not make it out. The face, somehow, fenced me off. It refused to disclose its secret. Force, of course, there was, plain enough. No one could mistake the masterfulness, the directness of purpose, the hard energy. But there I stopped. The compact outline had no suggestiveness in it. There seemed no inviting problems to be worked out: no vague impressions: no attractive obscurities: no ins and outs: no minglings: no fancies: no dreams. You left off at the face. You never got deeper. The clear clean surface repelled all inquiry. It prompted no curiosities. It simply asked you to take it or leave it, just as you liked. It was quite indifferent to influence from outside. It remained, fixed and unelastic, betraying nothing of what was passing before or behind it. After all my very best endeavour to be interested, I left off exactly where I had begun.

Our photograph shows Chamberlain when he was still a youthful

radical; but in any case his face proved as apparently immune to age as it was to emotion. In *Vanity Varnished*, P. Tennyson Cole described how he visited Chamberlain at Birmingham to execute a portrait just before the statesman's stroke:

> Talk of that school-girl complexion! It is, as a matter of fact, more often talked about than seen. Least of all, then, did I expect to find it blooming on the cheeks of this seventy-year-old statesman! Yet, sure enough, there it was. To me quite the most astonishing thing about Mr. Chamberlain, as I scrutinized him closely at his first sitting with me, was that his face was almost unlined. Never had I seen so young a face on so old a man. It was a face as smoothly modelled as a comparatively young woman's – and there were no face-lifting operations in those days, mind you! At length, near the mouth, I did discover a passing wrinkle. So, to give the right note of veneration to the portrait in view of the ripe age of the sitter, I managed to get this on to the canvas. But when the portrait was completed this wrinkle evoked Mr. Chamberlain's only criticism. 'Surely, Mr. Cole,' he demurred, 'there is no line so heavy as that on my face! Please take it out.'

A footnote to the story of Chamberlain's Dorian Gray mask is Speaight's account of how he went to Birmingham to take the last formal photograph of the old statesman in 1911. Chamberlain was shown with his son, Austen, and grandson, 'Little Joe', and Speaight tells one of the tricks he learnt for keeping the sitter happy:

> The only book which seemed to amuse Mr. Chamberlain was a bound copy of Hazelden's pictures in the *Daily Mirror*. Noticing this, I turned to Mrs. Chamberlain and said, 'Would it not be better if we gave Mr. Chamberlain a more serious-looking book?' She said, 'He won't like it if you take this away from him. You must alter it afterwards.'

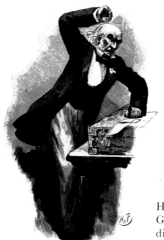

Harry Furniss' cartoon of Gladstone in action at the dispatch box

For the basilisk visage of Chamberlain, the studio photograph was ideal. But the limitations of this art form become apparent when we look at the photograph of Gladstone (page 129). The deep runnels

from nose to jaw show the moral fury of the man; the great coal eyes smoulder in their sockets – those eyes of which the mere unhooding could quell a meeting. But the essence of Gladstone was action, unresting motion, resistless emotion. Harry Furniss, the Victorian cartoonist whose caricature reproduced here does justice to the real Gladstone, said in his *Confessions*, 'During a great speech I have seen the flower in his buttonhole fade under his flow of eloquence, seen the bow of his tie travel round to the back of his neck'. It is here that the modern Press photograph scores over the old studio photograph.

Today studio photography is in decline. Already in 1938, Christopher Isherwood, in a virtuoso passage of his autobiography, *Lions and Shadows*, on the revelations of photograph albums ('. . . we look deeply into their faces, reading, in Time's cipher, everything that is secretly written there . . . Every attitude, every gesture, seems charged with meaning . . .') spoke only of 'snapshots'. Today the crassest amateur can buy a good camera that does most of the work for him. A photographer at Bassano and Vandyk's studio, who took my picture in 1968 (afterwards milking out of the not yet raddled face every incipient wrinkle and fledgling crows-foot) told me that the abolition of debutantes and court presentations had hit their business especially hard. For images of some of us, posterity will have to rely on a strip of photographs taken in an automatic kiosk-machine, with an uninspiring word, such as 'Fotome', on the back, instead of the copperplate and curlicues of yore. Though there is a ray of hope: in New York, John Dornes has revived plate photography, dressing his sitters in Victorian clothes and mounting the results in Victorian-style gilt frames with his name and address in gold on the back. When I sat to his assistant, wearing Gladstonian topper, wing collar and stock, in a New York antiques market – a rather public performance – a friend of the assistant's passed by and one of those characteristic American exchanges of affectionate contumely took place:

> *Friend:* You've got a good one there!
> *Dornes' Assistant:* Yeah, and you'd look good, too, with your head on a tray and an apple in your mouth.

It struck me that the difference between this kind of savage repartee and a courtly epigram is precisely that between a snapshot and a studio photograph: the one a sudden extempore, the other calculated to the last detail, with nothing awry. And each can tell the truth – or lie like the devil.

The Techniques of Victorian Studio Photography

Although the Daguerreotype process was announced in 1839, it was not until after 1840, when improvements in the chemical process and the introduction of high-speed lens designs reduced exposure times to around a minute, that commercial portraiture became possible. W. H. Fox Talbot's rival calotype process, using paper negatives, was little used for commercial work, being more suited to landscape and architectural photography. Since the Daguerreotype image was very fragile, it was protected by glass in a decorative case or frame, rather as miniature paintings were presented. The images were normally reversed, as in a mirror, and each was unique. If more copies were required, multiple sittings were necessary. A small portrait Daguerreotype, two by two and a half inches, might cost a guinea. The cost of larger sizes increased proportionally.

The introduction of the wet collodion process by Frederick Scott Archer in 1851 revolutionized portrait photography. The new method, free of patents, gave high quality negatives on glass, from which any number of copies could be printed. It was soon discovered that the collodion image, inherently light in tone, would give a positive image directly if backed with black paint or velvet. These collodion positives, or Ambrotypes as they were known in America, could be produced very cheaply. By the mid 1850s there were very large numbers of photographers throughout the country offering ready framed or cased portraits for as little as a shilling. The glass positives were often mounted in cases similar to those used for Daguerreotypes, which went rapidly out of favour, and by the late 1850s the earlier process had gone out of general use. The collodion positive process, applied to black enamelled tinplate, could be used to give a finished image in a very short time after exposure. This Ferrotype or Tintype method was even cheaper to operate, and from around 1860 sixpenny portraits were offered by itinerant photographers, bringing them within the reach of all but the very poorest families. This method was in use up to and even after the Second World War.

Another big step towards the popularization of photographic portraiture came with the introduction of the *carte-de-visite* photograph. In 1854 André Disderi, a Parisian photographer, devised a multiple-lens camera, with which a number of poses could be recorded on a single plate. The printing costs were thus greatly reduced and the small individual pictures were mounted on stiff cards about four inches by two and a half. *Carte* photographs became widely popular from 1860, and a photographer of some quality might charge one

guinea for a dozen *cartes*. Although popular until the turn of the century, after 1866 the *carte-de-visite* was rivalled by the cabinet photograph. Similar in presentation to the *carte*, with an elaborately printed mount, the cabinet was much larger, about four inches by five and a half. In the 1880s, a large studio might charge two guineas for a dozen cabinets; some, like Bassano, made a fee of one guinea for posing, and then sold cabinet prints at two shillings and sixpence each.

The collodion process had made only a small reduction in exposure times, which even in a well-lit studio were still as long as a minute, or even more if the light was poor. The gelatin dryplate process, first described by Dr R. L. Maddox in 1871, which came into general use around 1880, greatly reduced exposure times. Exposures of only a few seconds were possible in good conditions in the studio. The new process permitted the manufacture of plates the properties of which remained satisfactory for long periods, thus reducing both the staff and the time needed in the darkroom.

The design of professional portrait studios remained virtually unaltered from the beginning of photography until the First World War. Daylight was the principal source of illumination, and since as much light as possible was needed to keep exposure times to manageable lengths, the studios were glass roofed and glass walled. Moveable blinds and curtains enabled the operator to adjust both the quantity and distribution of light to accommodate different sitters at different times of the day. Artificial light was not employed until the advent of the faster dryplate, and even then was not generally used until after the First World War. A few photographers used arc lamps, like those designed by Van der Weyde, using up to 10,000 candlepower electric arcs in large umbrella-like reflectors. Such lamps were noisy, smelly and dangerous to the operator, who was exposed to high levels of ultra-violet radiation. Contrary to popular belief, burning magnesium powder was rarely used for professional portraiture.

The studio was equipped with a range of backdrops on rollers, various properties ranging from imitation masonry to toys for children, and posing chairs. Head rests were generally employed, to support the sitter's head during the long exposure. They might be free standing, concealed, often imperfectly, behind the sitter, or be part of the posing chair. 'Eye rests' – small pictures on adjustable stands – might be used to give the sitter a point at which to look, to reduce eye movement during the exposure. Adjustable screens, shades and reflectors, were used by the photographer to give a fine adjustment to the lighting on the sitter. To make the customer feel relaxed, the studio often contained much of the paraphernalia of the Victorian drawing room – potted plants, paintings, furniture and so on.

Studio cameras were usually of simpler but heavier construction than the general purpose field camera, whose extensive range of ad-

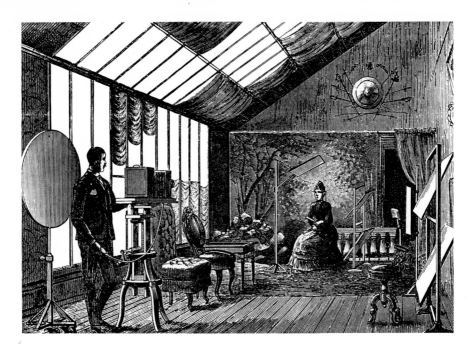

A typical daylight studio of the late 19th century, containing the classic heavy studio camera, reflectors, neck clamps and a range of props, including elegant chairs, fake rocks and a painted sylvan scene

justments was necessary to cope with a wider variety of subjects. The typical later Victorian studio camera was of massive construction, with bellows of square section connecting the front lens panel with a rear panel carrying the focusing screen and the plate holder. A wide focusing range allowed the camera to be used for groups or for close-up copying work. Apart from focusing, the only other movement normally found on the studio camera was a swing back, allowing the plate to be tilted relative to the lens, permitting the photographer to make the best use of the very shallow plane of focus of the portrait lens. Although simple, silent studio shutters were in use by the end of the century, most exposures were still made by removing and replacing a lens cap.

Since exposure times had to be kept to a minimum, portrait lenses had to have great light gathering capacity. The very first lens designed especially for photography was created in 1840 by Josef Petzval. His lens, with four glass elements, had a maximum aperture of f/3.6; this design, with minor variations, remained the standard for portrait lenses throughout the last century. The Dallmeyer portrait lens, based on the Petzval design, could be adjusted so as to give a soft focus effect when required, to flatter the sitter.

Most studio cameras were designed to take plates of at least whole-

plate size (6½ by 8½ inches), but most portraiture was done in a smaller format, notably in the *carte* and cabinet sizes. They were usually taken on a large plate moved, between exposures, in a repeating back fitted to the large camera. The camera was carried on a heavy wooden stand, usually of three-legged construction and fitted with castors for mobility. The camera could be raised, lowered and tilted so as to frame the sitter appropriately. The camera would be set up and approximately adjusted before the sitter was posed. Then, under a black cloth, to exclude light from the focusing screen, the photographer would make final adjustments, before inserting the plateholder. With the lens cap on, the darkslide would be withdrawn, uncovering the plate inside the camera, and the cap was then removed to make the exposure. After the appropriate interval, the cap was replaced, the darkslide replaced, and the plateholder removed to the darkroom. The sitter would normally wait while the plate was processed, in case another sitting was necessary. Proofs, often unfixed to make them impermanent, would be supplied to the customer as a basis for ordering the final prints.

In a small studio, the owner would have only one or two assistants, who would carry out all the duties of darkroom, studio and reception. Larger establishments, like those of Bassano or Elliott and Fry, would have much bigger staffs. Under the owner, who was usually the principal photographer, but who might be just a business manager, would be a chief operator. If he were responsible for posing and lighting the sitter, he might earn two or three guineas a week, but less if he worked under the direction of the principal. Next in the hierarchy was the retoucher, who worked on the developed negatives, removing defects and softening lines to flatter the subject; he or she could expect not less than two guineas a week, if skilled. The printer worked with the retouched negatives, printing, vignetting, toning and so on. A competent worker would be paid thirty shillings a week. A darkroom worker or assistant operator, who would have prepared the plates in the wetplate period, was thought to be less necessary with the coming of the dryplate. Often he was a young man, learning the trade, and thus would not receive more than a pound a week at best. Girls were usually employed to spot the prints, removing faults and blemishes in the paper, and to mount the finished prints on the card supports; they might get eight to sixteen shillings a week. For this, they might have to deal with up to 150 prints a day. Finally, a book-keeper and receptionist, usually a woman, was required to meet customers, make appointments, handle the cash and so on. She would be unlikely to earn more than other girls in the establishment.

The London Studios of Alexander Bassano and Elliott & Fry

Alexander Bassano was born in 1829 and christened Alessandro, a name which he later anglicized. Although evidently of Italian ancestry, and bearing the name of a family of painters and sculptors which flourished in 16th-century Italy, almost nothing is known of his background or how it was that he came to set up in business in London, rising to become one of the leading Society portrait photographers of his day. He married an Englishwoman, Adelaide Lancaster, by whom he had three children. To his grandchildren he was known affectionately as 'Gimpy'. He died in 1913 while staying with his son-in-law, the Rev. Sergeant, at St Martin's Vicarage, Acton, and was buried in Kensal Green Cemetery in west London.

The photographic studios which he founded in the 1850s operated in London at 122 Regent Street until 1877, when they were moved to 25 Old Bond Street. After Bassano's death, the company, which continued to bear his name, moved twice again and in 1963 was amalgamated with that of Elliott & Fry.

Joseph John Elliott and Clarence Edmund Fry, about whom almost nothing is known, established their business as 'Photographic Artists' in Baker Street in 1863, the firm continuing to occupy premises in the same street for the hundred years up to their amalgamation with Bassano Ltd.

In 1880, H. Baden Pritchard, Editor of *The Year-Book of Photography* and one-time Honorary Secretary of the Photographic Society of Great Britain, visited the studios of a number of eminent British and Continental portrait photographers, reporting his experiences in *The Photographic News* in a series of 'At Home' articles. In 1882 these were reprinted in book form as *The Photographic Studios of Europe*.

Pritchard went to the studios of both Alexander Bassano and Elliott & Fry. At the latter's 'Talbotype Gallery' in Baker Street he noted that their somewhat higher than average fee of one guinea per sitting had provided the proprietors with sufficient wealth to enable them to adorn the walls of their premises with many important contemporary paintings, insured, Pritchard informed his readers, for an undisclosed, but quite staggering sum of money. At this time, of course, the studio photographer was dependent on daylight, and Pritchard found it amusing to relate that one of the studios in the establishment was so ill-lit by a window directly above the sitter's head that it could never be used for photographing the glare-inducing

surface presented by a bald man's head. In the main studio Elliott & Fry's discerning clientèle could choose any one of a selection of 26 backgrounds, lowered like stage sets – one of the most popular depicting the Royal Park at Windsor. As was the common practice, the studio and darkroom were kept well apart – emphasizing the distinction between the relative status of the newly-created profession of artist-photographer and that of the simple technician. All the routine work of printing and finishing was executed by a group of workers out of London, at Barnet. Once printed, the negatives were coated with shellac for protection and returned for storing in a series of large racks in the Baker Street studios. Like all photographers, Elliott & Fry would have their periodic house-clean, when many of the older negatives would be destroyed to make space for new ones. In his 1890 publication, *Photography as a Business*, Henry Peach Robinson recommended that studio photographers should contact former clients after five years or so, advising them that it was intended to destroy the negatives of their last sitting unless they specifically requested that they be preserved. In this way, the photographer could cover himself against any later accusation of having recklessly weeded out portraits which might some day be required, and naturally many clients took this opportunity to re-order prints at the special rates offered for portraits from existing negatives. Portraits of notable personalities would, of course, be retained for many years, and those which have survived are especially those of people who had been invited to sit at no charge. This is because under copyright law, provided the sitter did not pay for the session, ownership of the negatives was vested with the photographer. In return for a selection of prints donated to the client, the photographer thus received not only the opportunity to reproduce them in publications, but also the prestige of adding such distinguished persons to his list of customers.

After visiting Alexander Bassano's studio, Pritchard described his impressions thus:

> Mr Bassano's gallery in Old Bond Street at once impresses you with this idea: it is exactly the sort of studio we should all of us like to have. A handsome suite of rooms on the first floor in a fashionable thoroughfare, a *clientèle* that troubles you only in the season, and sitters who do not object to pay well for the attention they receive. Listen to this, good friends, who believe that photographic portraiture is no longer worthily recompensed. 'Mr Bassano's terms are: Two guineas for the sitting, which sum entitles the sitter to either twelve cabinets or twenty *cartes-de-visite* photographs.'

Pritchard also described the many large carbon prints which graced the walls of the elegant drawing rooms which comprised Bassano's reception area, referring in particular to 'A magnificent picture of the Duke of Connaught' and to a number of plaster busts of the Duke, the Prince Imperial and others executed by Bassano himself, who was a competent amateur sculptor as well as a very

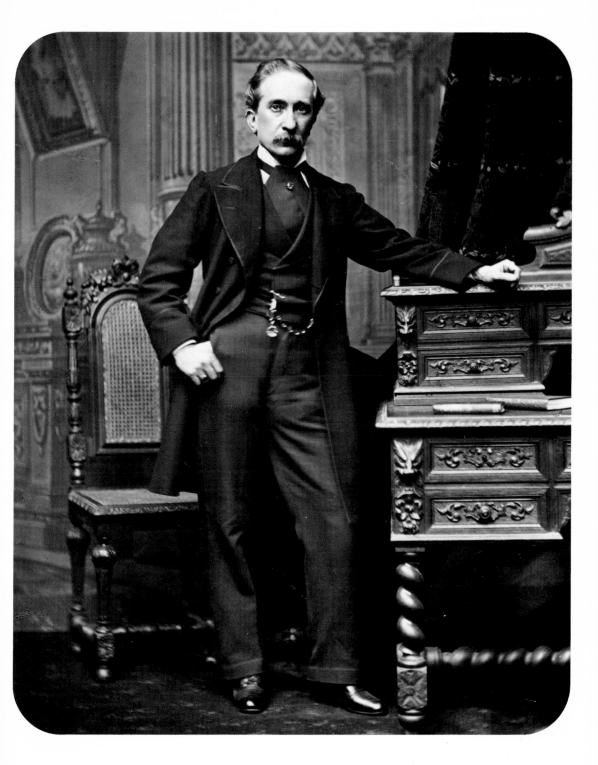

Alexander Bassano

successful photographer. When visitors were ready to proceed from these rooms to the studios above, a signal was given by the attendant staff by means of a set of ivory whistles. The principal studio measured 26 feet in length and was remarkable for its 80-foot panoramic background, mounted on rollers, with every imaginable indoor and outdoor scene, so that the sitter could choose to be photographed against anything from a mountainous landscape to a genteel living room. Pritchard also noted the presence of *real* furniture. Bassano had only the finest piano, splendid bookcases filled with genuine books, and oriental carpets – none of the usual phoney papier-mâché rocks and cardboard balusters.

In this well-appointed Old Bond Street studio, Bassano carried out his more important work, using a Piccadilly branch studio for 'impromptu' work. Like Elliott & Fry, his printing was carried out by a large team of workers at premises in north London, at Kilburn.

Before leaving, Pritchard asked Bassano if he would reveal the secrets of his success. Bassano answered:

> Secrets? Lord bless you! I have none . . . I have met with some success, but the only secret which has tended to it has been that I have brought to bear upon my work whatever art cultivation, inclination and circumstance have fostered.

The Plates

Marie Tempest
1864 - 1942

During the first half of the 19th century, the Victorian theatre was considered the inferior of the ostensibly more edifying entertainment offered by the opera, the circulating library and the public lecture. After 1850 it regained its respectability. This was the age of the great actor-managers – Charles Kean, Herbert Beerbohm Tree and Henry Irving, whose performances and productions were patronized by the highest society. Yet when, at 17, Marie Tempest declared her intention to become an actress, she was driven directly to 10 Downing Street by her horrified grandmother, and subjected to a lecture by Mr Gladstone himself upon the depravity of women in the theatre.

She had been a wilful and rather arrogant little girl, two traits of character which stood her in good stead, for the lecture failed, apparently, to impress. At the age of 21, her grandmother dead and a rigorous training in singing at the Royal Academy of Music as well as a failed marriage behind her, Marie performed in her first operetta. The following year she had a remarkable success in *Dorothy*, a light opera in which she sang the leading role, which ran for 931 performances. Perhaps some vestiges of Mr Gladstone's warning remained in her mind, for she was noted for extreme prudishness. In the first month of her first professional engagement, a manager ventured to touch her leg as she climbed a staircase. She stabbed him so violently with a hat pin that he collapsed.

After her success in *Dorothy*, she was sent on tour to the United States and for five years was the star of light opera in New York. Her voice was praised, but she was unpopular with the critics and the press, whom she froze with her English reserve. On her return to England she became the prima donna of Daly's Theatre in London, which, with the Prince of Wales's and the Shaftesbury Theatre, established the prestige of the English musical stage.

On stage, Marie was self-disciplined, professional and popular; audiences loved her. Elsewhere, she was aloof, brusque and temperamental. Eventually, dissatisfied with the superficialities of comic opera, she quarrelled with her producer over whether she should wear a pair of long trousers on stage and left to begin a new career as a comedy actress. She was entirely without training, and built up her first part, as Nell Gwynne in *English Nell*, a play written originally for Ellen Terry, gesture by gesture and phrase by phrase, before a mirror. The critics praised her vivacity and her diction. In her next part, as Peg Woffington in *Masks and Faces*, she proved herself mistress of her craft. She was brilliantly funny and adored by the public. The critics considered that she brought life to the thinnest drama and hinted at a talent for serious dramatic parts, which was, however, never developed.

She designed and bought her own dresses for her part in *English Nell* and as she grew more wealthy began to dress at the great couturiers. Her creations were talked about among the public and described in the press and she began to set fashions.

Marie Tempest continued to act until the age of 78. Her talent and popularity survived world tours lasting for years, through wars, depressions and generations. In 1925 Noël Coward wrote *Hay Fever* for her; in 1935 James Agate, one of the greatest critics of the day, declared that he was 'tired of toiling over the perfections of Miss Tempest'.

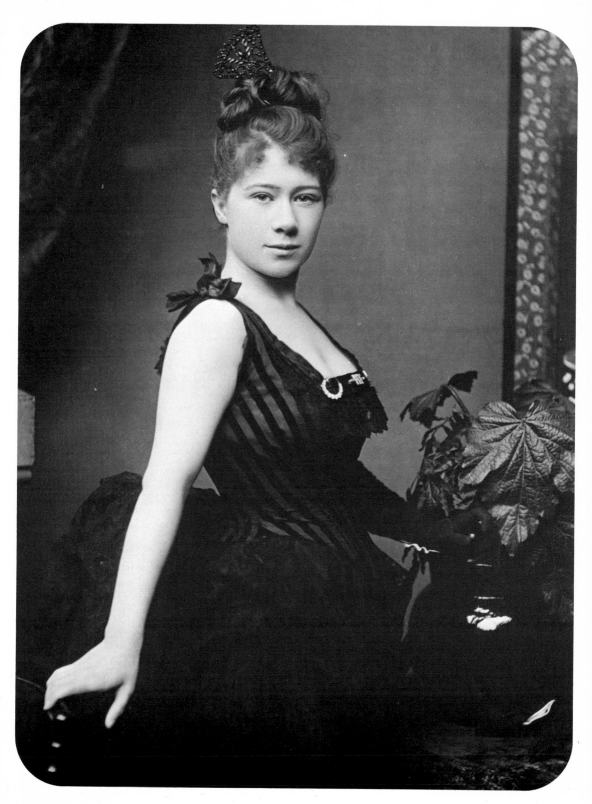

Henry Irving
1838-1905

John Henry Brodribb took the stage name of Henry Irving in 1856 at the time of his first public appearance. The son of a Somersetshire shopkeeper, he had acted as a child at school in London and, aware of his vocation, continued to study acting after leaving school and working as a clerk. After performing in the north of England and in Scotland, he first appeared in London in 1859 and then travelled extensively, performing throughout the British Isles and in Ireland. By the age of 28 he could look back on 10 years' stage experience during which he had played nearly 600 parts.

Irving first met Ellen Terry in 1867 when she played Katherine opposite his Petruchio in *The Taming of the Shrew*. This marked the beginning of the long personal and professional partnership which Ellen described in detail in her autobiography.

Irving's real rise to fame occurred when he appeared at the Lyceum Theatre in 1871 in *The Bells*. It brought him overnight renown and indeed, whenever it later appeared that his popularity might be waning, a new production of *The Bells* was guaranteed to revitalize the image of the Greatest Living Actor, the rôle which he was to play for over thirty years. In 1878, Irving took over the management of the Lyceum and opened as Hamlet – another of his most acclaimed parts – with Ellen Terry as Ophelia.

After 1883 he toured the United States eight times and was enthusiastically received. His many productions included a memorable version, without scenery, of *The Merchant of Venice*, performed at West Point Military Academy.

In 1892, the year in which this photograph was taken, Irving had opened in *Henry VIII*. A number of critics noted the remarkable similarity between Irving's Wolsey and the familiar visage of Cardinal Manning who had died the week after the play opened. Sir Robert Peel even wrote to Irving, addressing him as 'My Lord Cardinal' and informing him that 'Your Grace just looked what Wilberforce once said of Manning, "the very incarnation of evil" '. Later in the year, Irving revived another favourite, *Richelieu*, inviting comparison between his portrayals of two worldly cardinals. On 6th July, he visited Dublin with the artists Leighton and Alma-Tadema to receive the degree of Doctor of Letters from Trinity College – the first actor to be so honoured by a university. The year 1892 was also a disturbing year for Irving. His son, Laurence, accidentally wounded himself in the chest with a revolver shot. In November, Irving opened in *King Lear*, but was slated by the critics for speaking inaudibly. He was poorly received on numerous other occasions. In 1898, for example, two plays, *Peter the Great* by Laurence Irving and *The Medicine Man*, flopped and were closed almost immediately. This was followed by a streak of ill fortune in which most of his scenery was destroyed by fire, he caught pleurisy and was so financially embarrassed that he was compelled to sell his splendid library. Unable to afford repairs to the Lyceum, he lost his licence to manage it.

Despite such setbacks, Irving's dramatic triumphs overshadow his disasters, and he stands out as the dominant figure in the late Victorian theatre, being in 1895 the first actor to be knighted and receiving in death the ultimate accolade of burial in Westminster Abbey.

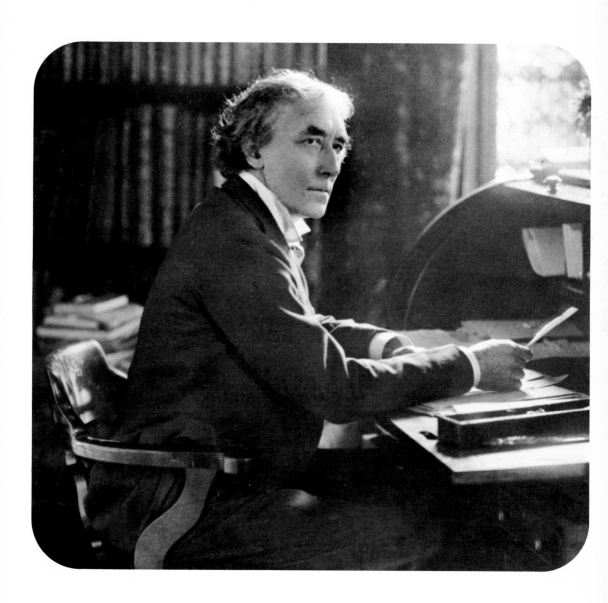

Charles Hawtrey
1858-1923

Charles Hawtrey, a popular actor, was one of ten children of the Rev. John William Hawtrey. After attending Eton and Rugby Schools, he went up to Oxford University but left after a year to act under the stage name of Charles Bankes. He achieved considerable success as Douglas Cattermole in *The Private Secretary*, his own rewritten version of Gustav von Moser's *De Bibliothekar*, and created many notable roles in his career. He also managed numerous London theatres, including the Globe and the Comedy, and was knighted a year before his death.

A passionate sportsman and inveterate gambler, who is said to have won the then colossal sum of £14,000 on a single horse race in 1885, Hawtrey excelled in playing parts which in some ways reflected his own lifestyle. He appeared frequently in farce and light comedy in the role of a gambler, cheat or erring husband, achieving, it is said, complete naturalness. He seldom attempted any part which demanded pathos or more dramatic ingenuity than was required of his typecast performances as a blustering rogue. His consistent style of acting and the remarkable similarity of his many parts were described by Lytton Strachey:

> The English playgoer who has an evening on his hands, and who wishes to run no risks in his search for entertainment, can always make sure of satisfaction by the simple plan of going to see Mr Hawtrey. Other actors may provide a more elaborate, a more highly seasoned, or a more *recherché* fare, but none can be relied upon with quite the same kind of certainty. With Mr Hawtrey alone one is absolutely safe from any danger of being bored, or teased, or disgusted; his dishes are simple, unassuming, unvarying, and always perfectly cooked. Yet it is true that what Mr Hawtrey has to offer, though it certainly cannot be called exotic, is possessed of a flavour of its own which is quite unmistakable. The flavour is difficult to analyse; but whatever else might be said about it, one of its characteristics is obvious enough – it is peculiarly English; indeed, it is hard to think of anything more completely and typically English than Mr Hawtrey's acting. For this reason, no doubt, our foreign visitors are apt to be puzzled by his success. To them he is, of all our institutions – and surely he deserves to be described as an institution – perhaps the most mysterious. When they have understood our hansoms, our cooking, and our table of precedence, they are still baffled by Mr Hawtrey . . . Where Mr Hawtrey is concerned, the play is emphatically *not* the thing. What is the thing is simply and solely Mr Hawtrey.

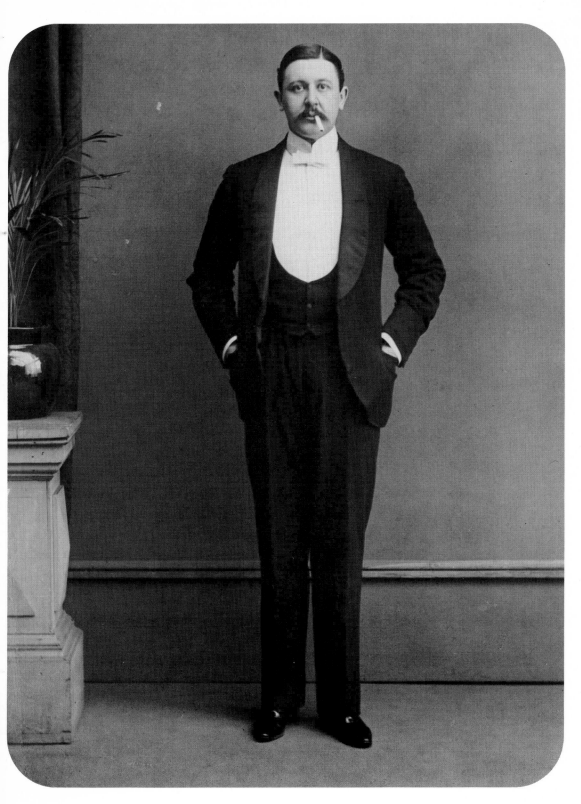

Ellen Terry
1848-1928

Ellen Terry, England's leading Shakespearian actress of the Victorian theatre, was born into a family of strolling players. She made her first stage appearance at the age of nine in a production of *The Winter's Tale* under the management of Charles Kean, the first of the great Victorian actor-managers. Coached by Kean and by her Irish father, she was a serious professional, lauded by the critics, but at the age of 15 she suddenly left the theatre, obsessed by a love affair with George Watts, the distinguished painter, and married him in 1864. 'When I was alone with Mother one day,' she later explained in a letter to George Bernard Shaw, 'I told her . . . I *must* be married to him *now* because I was going to have a baby ! ! ! ! *and she* believed me ! ! Oh, I tell you I thought I knew everything then, but I was nearly 16 years old then – I was *sure* THAT kiss meant giving me a baby!' The marriage lasted for less than one year.

Ellen later asserted that she had left the stage without 'one single pang of regret', and afterwards had to be 'practically *driven* back'. In 1867 she appeared, with Sir Henry Irving, as Katherine in *The Taming of the Shrew*, but left the theatre again the following year to elope with Edward Godwin, a young architect whom Oscar Wilde later praised as 'one of the most astute spirits of this century in England'. She lived idyllically in the country with her love, by whom she had two illegitimate children. These years she looked upon as sacred, their happiness marred only by Godwin's debts; their end finally brought about by his neglect.

Early in 1874 Charles Reade, a close friend during her adolescence, recognized her in a country lane and brought her back to the stage to appear in his own productions. The following year she was cast as Portia in *The Merchant of Venice*, one of her most magnificent performances. The audience threw flowers at her feet. 'Never until I appeared as Portia at the Prince of Wales's had I experienced . . . the feeling of the conqueror,' she recalled in later years. In her next part, Joseph Knight, one of the greatest Victorian theatre critics, wrote that he had experienced the advent of genius on seeing her act.

It was as Irving's leading lady and mistress between 1878 and 1902, that Ellen Terry realized her maturity as an actress. In an age when pompous, rhetorical and monotous acting was the norm, she brought naturalness of style and manner, and the faultless enunciation of a well-trained voice. She suffered from Irving's professional jealousy and selflessly undertook minor roles in his productions. She recorded that her greatest disappointment had been to abandon her long hope of playing Rosalind because of the lack of a suitable role for him.

Her 70-year-long career, which began with the provincial circuits of Victorian troupers, ended with parts in the first talking pictures of the early 20th century.

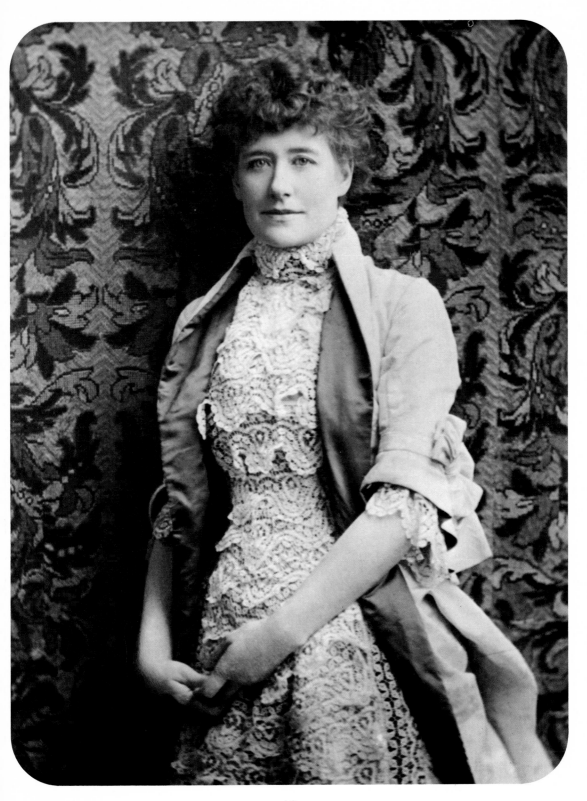

Edvard Grieg
1843-1907

Of Scottish and Norwegian descent, Edvard Grieg was born in Bergen, where he spent most of his life. He showed an early aptitude for music and was sent to study at the Leipzig conservatoire. There he was influenced by the work of Mendelssohn, Schumann and Chopin. He also studied in Copenhagen under the Danish composer, Niels Gade. His association with his fellow countryman, Rikard Nordraak, a devotee of Norway's traditional folk songs and dances, led Grieg away from German and other foreign influences towards an intense nationalism – at a time when Norway sought national identity and independence from Sweden. After Nordraak's death in 1866, Grieg single-handedly fostered Nordic music, which gained steadily in popularity. His meeting in 1869 with Liszt, who admired his work, was an immense fillip to the promotion of his compositions overseas.

Only after considerable persuasion, Ibsen managed to obtain Grieg's co-operation in composing incidental music to his *Peer Gynt*, first performed in 1876. Grieg was a frequent visitor to England, and was much admired in the late 19th century. In 1888 he scored an immense success in London with his piano concerto and 'Two Melodies for Strings'. In 1894 he was made a Doctor of Music at Cambridge University.

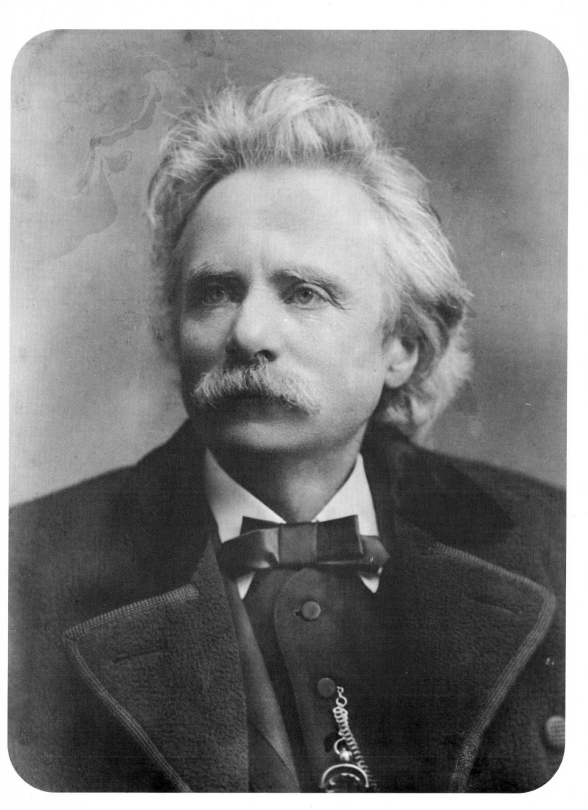

Franz Liszt
1811 – 1886

Regarded as the greatest pianist of his day, Franz Liszt was born in Hungary, where he demonstrated his prodigious talent by performing publicly at the age of nine. Two years later he attracted the praise of Beethoven. After studying in Vienna and Paris he toured Europe, drawing large audiences who were fascinated not only by his virtuosity but also by his flamboyant manners both on and off the stage. He associated with many leading French literary figures and lived with the Countess Marie d'Agoult, an aristocratic novelist. Later he shifted his attentions to the Princess Carolyne zu Sayn-Wittgenstein.

Through this association with the royal family of Weimar, he was there appointed Court conductor. Under his influence Weimar became the musical capital of Germany. In 1865, he took minor orders in the Catholic Church and became known thereafter as the Abbé Liszt.

Undoubtedly a colossal figure in the history of music, Liszt was a prolific composer and a highly-regarded teacher. One of his pupils, an American, Amy Fay, recalls her impressions of him:

> I recognized him from his portrait . . . Liszt is the most interesting and striking-looking man imaginable. Tall and slight, with deepset eyes, shaggy eyebrows, and long iron-grey hair, which he wears parted in the middle. His mouth turns up at the corners, which gives a most crafty and Mephistophelian expression when he smiles, and his whole appearance and manner have a sort of Jesuitical elegance and ease. His hands are very narrow, with long and slender fingers that look as if they had twice as many joints as other people's! They are so flexible and supple that it makes you nervous to look at them . . . But the most extraordinary thing about Liszt is his wonderful variety of expression and play of feature. One moment his face will look dreamy, shadowy, tragic. The next he will be insinuating, amiable, ironic, sardonic; but always the same captivating grace of manner . . . All Weimar adores him, and people say that women still go perfectly crazy over him.

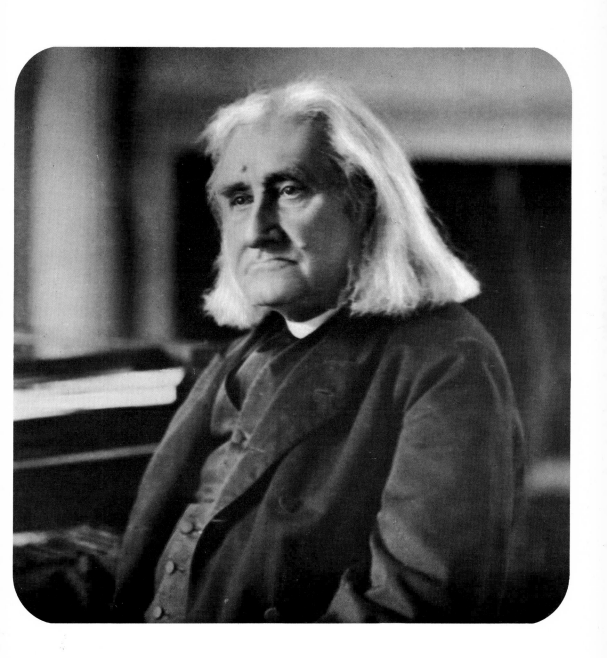

Sir Arthur Sullivan
1842-1900

The year of this photograph, 1891, was an important one in the life of Sir Arthur Sullivan, then the foremost name in British musical circles. On 31st January *Ivanhoe*, Sullivan's long-awaited first grand opera, was performed before a brilliant audience, the first production to be staged at D'Oyly Carte's magnificent, new and electrically-lit English Opera House, now the Palace Theatre, London. Great hopes had been expressed for the success of Sullivan's new work; it was to be England's first national opera. The scenery and staging were magnificent; the costumes breathtaking, the orchestra enormous. The reception on the first night was enthusiastic and on the following day the notices were complimentary. George Bernard Shaw alone failed to give a favourable review.

Fame had come easily to Arthur Sullivan. Born in Lambeth into a 'respectable' poor family, he was endowed with a gift for music, the wit and social sophistication of his Irish father, and a kidney complaint which troubled him all his life. During painful attacks of this illness he is said to have composed his gayest and most care-free music. By the age of eight he could play all the wind instruments his father, a bandmaster at the Royal Military Academy, could teach him and had composed his first anthem. From choirboy at the Chapel Royal, which supplied choirs for royal ceremonies, he became the first holder of the Mendelssohn Scholarship at the Royal Academy of Music. He later studied in Leipzig. In 1862 his incidental music to Shakespeare's *Tempest* was produced at a concert in the Crystal Palace, London's great centre for musical performances, and was repeated there the following week, an unprecedented honour.

In 1869 Queen Victoria commanded Sullivan to present her with a complete set of his published works; he was her second favourite composer (Mendelssohn stood highest in her esteem). In the same year, with his close friend, Sir George Groves, the influential musicologist, he discovered Schubert's lost *Rosamunde* manuscript. He was 27 years old, honoured by the highest personages in the English musical world, and feted by Society.

Like Wagner, Sullivan aspired to a standard of living he felt to be the due of an artist of his proven calibre. He resented the need to teach, an occupation which he hated, and to hire himself out as an accompanist. Through wealthy and influential friends he was given a post as church organist at a stipend of 80 pounds a year, and a commission to write the music for an adaptation of *Box and Cox*, a popular farce. Comic opera, he found, was financially viable. In 1871 he was introduced to William Schwenk Gilbert and in 1875 their famous partnership began with *Trial by Jury*, a light opera so successful that it ran for more than a year. Sacrificing high ideals – he hoped temporarily – for immediate remuneration and an agreeable occupation, he dedicated himself to the scores for the full-length operettas which, by 1889, had become a kind of national institution and which earned their authors fame abroad and enormous financial success. Although acclaimed in his day for his hymns and anthems, his ballads and for the music he composed for ceremonial and state occasions, Sullivan himself felt that his genius was best expressed in his oratorios and his great opera; 75 years after his death, it is for the light and inventive airs of his operettas that he is best remembered.

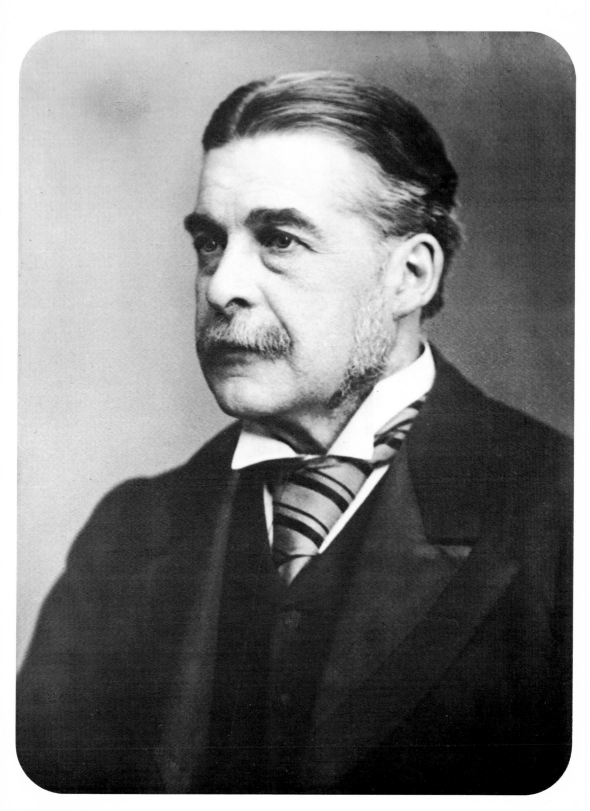

Richard Wagner
1813 – 1883

Unlike most of history's pantheon of great composers, Wagner was not a child prodigy. He came from a line of schoolmasters and tax collectors, among whom appears the occasional organist or minor singer. His musical education was perfunctory, and during his childhood his main preoccupation was with the Greek theatre.

In Leipzig in 1827 he wrote a drama, a Shakespearian tragedy: '. . . two-and-forty human beings died in the course of his piece,' he later remembered, 'and I saw myself compelled, in its working out, to call the greater number back as ghosts, since otherwise I should have been short of characters for my last acts'. He resolved to set it to music, and to this end began to study composition and to produce his first musical compositions, at the age of 15.

Though possessed of an unshakeable belief in his own genius, Wagner fought a hard battle for recognition. His first opera, *Die Feen*, written when he was 20, was never performed; another *Das Liebesverbot*, was staged only once. His life was dogged by disappointment and financial crisis – the results of bad luck, poor pay and his own incurable extravagance. Success eventually came to him at the age of 50 when, exhausted by failures, pursued by creditors and defamed by critics, the young king of Bavaria, Ludwig II, became his patron. Ludwig had heard *Lohengrin* at the age of 15 and had immediately immersed himself in a bizarre fantasy world based on Wagner's Germanic medievalism, lavishing vast fortunes on the building of such follies as the fairy-tale castle of Neuschwanstein. Sending his secretary to track down the impoverished composer, Ludwig settled Wagner's debts, and continued to do so until they became so heavy and Wagner's interference in affairs of state became so offensive to the Bavarian Government that Ludwig was forced to dismiss him. Nevertheless, the mad king's devotion to his idol continued until Wagner's death and they wrote to each other for many years.

In 1849 Wagner was wanted for revolutionary activities by the Saxon police who described him as a man of 'middle height, has brown hair, wears glasses; open forehead, eyebrows brown; eyes grey-blue; nose and mouth well-proportioned; chin round . . . in moving and speaking he is hasty.' His portraitists extracted various aspects of his complex personality. Kietz in 1842 depicted him as a visionary; Herkomer and Lenbach emphasized the nobility of his features and bearing; Renoir drew him in 1882 as an ageing maestro with piercing eyes.

Wagner dramatized his life; he lived in a style which he considered befitting to an artist; he dressed according to his conception of how an artist should dress; his hair he wore melodramatically wild. His speech was an oration, punctuated by cultivated effects and tones, and theatrical gestures. He dramatized music, and in so doing revolutionized its development and the techniques of composition.

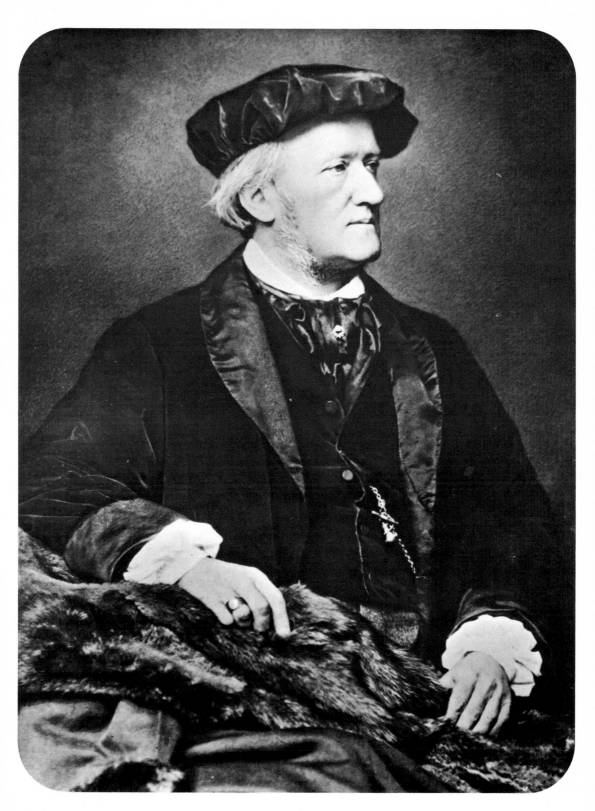

Ignacy Jan Paderewski
1860-1941

The son of a Polish peasant, a steward on a large country estate, Ignacy Jan Paderewski became an outstanding pianist, a composer of note, and a great statesman. He is said to have shown his first interest in the piano at the age of three.

While a student, he made his first concert tour, in Russia, and was abandoned, ill and penniless, by his young violinist companion. In a dream his father saw his son crying for help and sent him money.

In 1884 he studied in Vienna under Leschetizky, an exiled pianist, teacher and composer who, he said, 'taught me more in those few lessons than I had learned during the whole twenty-four years preceding that time'. He became the leading exponent of Leschetizky's novel musical interpretations and techniques, and began to perform them publicly. The 'glittering brilliance of his execution, . . . the wonderful originality of his readings and the ardour of his temperament' were praised by *The Times* in 1891. George Bernard Shaw described him as the leading pianist of his time, remarkable both for his musical culture and for his mind.

His strongly patriotic opera, *Manru*, he composed in 1901. It was repeated that year in six cities in the United States, where in 1895 he had set up the Paderewski Fund to aid musical education. Paderewski's political career began with his earliest American performances, when he collected donations for the Polish relief fund. Before the First World War he was thought to be the richest living musician. In 1910, as an expression of his intense patriotism to his country, he presented at his own expense a memorial commemorating the five-hundredth anniversary of the victory of the Poles over the Teutonic Order in the battle of Grunwald. His patriotism, his powers of oratory and his music combined to make him a great spiritual leader of the Polish people.

In 1919 he was nominated Prime Minister and Minister of Foreign Affairs of a Poland whose future independence was his most fervent hope. Later that same year he signed the Versailles Treaty on behalf of his country.

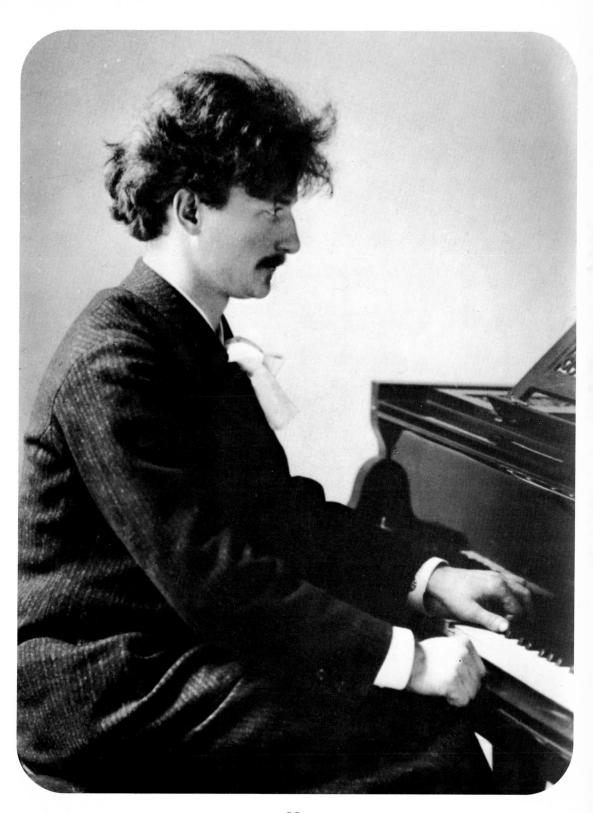

Thomas Carlyle
1795-1881

The son of a Scottish stonemason, Carlyle studied at Edinburgh University with the intention of entering the Church, but left without a degree and taught mathematics for a time. After studying law he began translating German books and writing, becoming a contributor to the *Edinburgh Review* and, ultimately, one of the 19th century's outstanding historians and commentators on the political affairs of his time. He lived in Cheyne Row, London, after 1834 and was a close friend of such distinguished men as Ralph Waldo Emerson and John Stuart Mill. Emerson first met Carlyle in London in 1833. They established an immediate intellectual rapport and began a correspondence which lasted until 1873. It was one of the most fruitful and certainly the most important transatlantic literary relationship of the 19th century. Emerson wrote of Carlyle:

> He was tall and gaunt, with a cliff-like brow, self possessed and holding his extraordinary powers of communication in easy command; clinging to his northern accent with evident relish; full of lively anecdote and with a streaming humor which floated every thing he looked upon.

Carlyle, in turn, described Emerson as, 'A most gentle, recommendable, amiable and wholehearted man'.

As a result of an accident, the manuscript of Carlyle's *The French Revolution* was destroyed while in Mill's possession, but Carlyle doggedly re-wrote it and saw his magnum opus acclaimed as a supreme example of contemporary scholarship.

Carlyle was painted, symbolizing 'brain-work', in Ford Madox Brown's masterpiece, *Work*, and throughout his life, frequently to his annoyance, was much painted and photographed, especially in his role as the grand old man of English letters. In J. A. S. Barrett's catalogue of these many representations, *The Principal Portraits and Statues of Thomas Carlyle*, James L. Caw, Director of the National Galleries of Scotland, refers particularly to 'Elliott & Fry's fine profile with hand raised to the cheek'.

Perhaps the best of the many contemporary descriptions of Carlyle is by the American author, Frank Harris, who wrote:

> He looked, I thought, the prophet; his clothes loose and careless, for comfort, not show; the shaggy, unkempt grey thatch of hair; the long head, the bony, almost fleshless face of one who had fasted and suffered; the tyrannous, over-hanging cliff forehead; the firm, heavy mouth and out-thrust challenging chin – the face of a fighter; force everywhere, brains and will dominant; strength redeemed by the deep-set eyes . . . beautiful, by turns piercing, luminous, tender-gleaming; pathetic, too, for the lights were usually veiled in brooding sadness broken oftenest by a look of dumb despair and regret; a strong, sad face, the saddest I ever looked upon – all petrified, so to speak, in tearless misery, as of one who had come to wreck by his own fault and was tortured by remorse – the worm that dieth not.

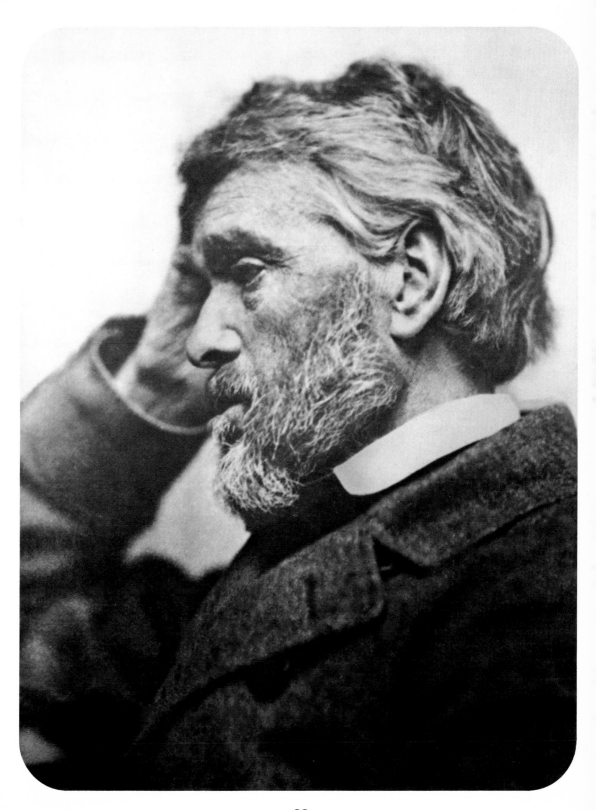

Ralph Waldo Emerson
1803-1882

In the spring of 1873, in his 70th year, Emerson sat for this photograph during a visit to London. He had made many new friends, including Burne-Jones, Gladstone, Ruskin and Robert Browning and had seen many old ones, including Thomas Carlyle. By now, however, the mental powers of America's foremost man of letters were waning. He could find his way to Carlyle's house, which he had visited many times before, only with the aid of written instructions.

Emerson made this trip, his third to Europe (and, on this occasion, also taking in Egypt) after his house in Concord, Massachussetts, had burned down and was being rebuilt, paid for out of a fund raised for his benefit by James Russell Lowell and other friends and admirers. He had bought the house after his first visit to Europe, in 1833, at which time he had met Coleridge, Wordsworth, John Stuart Mill and Carlyle. Previously, he had grown up in Boston where his father, William Emerson, was minister of the Unitarian First Church. He studied at Harvard, without distinction, and taught in his brother's school before becoming, though not fully qualified as a result of illness while at Divinity School, a preacher. Upon his return from Europe, under the influence of Wordsworth and European mystics such as Swedenborg, he had been compelled to reappraise his metaphysical views and, leaving his work as a minister following a theological dispute over the nature of the Last Supper, he now turned to lecturing, with increasing success, on philosophy, biography and literature. In 1837 he delivered an oration, *The American Scholar*, at Harvard. Urging American scholars to establish an original relationship with philosophy and the arts, removed from the dictates of European conventions, Emerson's speech was so eloquent that Lowell described it as, 'an event without any former parallel in our literary annals'. Soon afterwards, Emerson spoke before Harvard Divinity College, shocking orthodox theologians by his outspoken views on the role of the ministry and on the nature of miracles, and other Christian tenets.

Emerson went from strength to strength as a popular lecturer, many of his lectures being printed, with modifications, in a series of books. He visited England for the second time in 1847–48, meeting Dickens, Macaulay, Tennyson and other literary figures. By now he was as highly regarded in America as Carlyle in England; the comparison between them was humorously made in Lowell's *Fable for Critics* of 1848, in which he wrote:

> C's. the Titan, as shaggy of mind as of limb;
> E's. the clear-eyed Olympian, rapid and slim.

Taking a bold stand in many areas – in philosophy as a transcendentalist, in religion as rationalist, as an advocate of intuition and instinct as divine guidance, and above all as a champion of individualism – Emerson, through his public speaking in America and England and through his writings, became by the mid-century acknowledged as a leader of American thought.

A friend of Longfellow for 50 years, he attended his funeral early in 1882, only a few months before his own death. By then, and throughout the previous decade, his mind had faded so dramatically that he could not remember the name of the man whose memory he had come to honour. On his deathbed, however, he saw Carlyle's portrait on the wall and remarked, '*That* is the man, my man'.

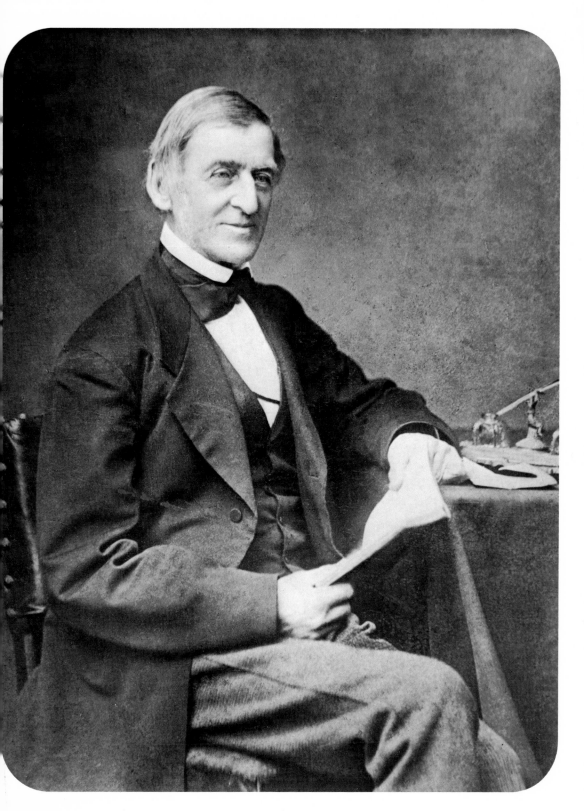

Thomas Henry Huxley
1825-1895

T. H. Huxley was regarded as one of the leading scientists of the 19th century. A biologist, he was chiefly noted for his advocacy, with modifications, of Darwin's views on evolution, and his trenchant controversies with orthodox theologians.

 The son of a schoolmaster, he stated that he had inherited from his father obstinacy, a hot temper and the ability to draw, and from his mother the rest of his character, including 'rapidity of thought'. He became a virtual agnostic at the age of 15, later coining the word to describe his philosophical standpoint. He decided to become a mechanical engineer, but turned to medicine under the influence of two sisters who had married doctors. On obtaining his degree, he was appointed surgeon on HMS *Rattlesnake*, a decaying naval vessel sent to survey north-east Australia. There he undertook his first scientific work, writing on the marine biology of the coasts they charted. The papers he subsequently published won him immediate fame and back in England he entered a circle of scientific men and began to lecture. In his journal of 1856 he resolved, 'to smite all humbugs . . . to give a nobler tone to science'. Through his lectures and writings, he became one of the country's leading popularizers of science, to the extent that Andrew Lang commented, 'In England when people say "science" they commonly mean an article by Professor Huxley in the *Nineteenth Century*'.

 In addition to acting as 'Darwin's Bulldog', Huxley entered into a long series of literary battles with Gladstone, who supported the Biblical account of the Creation, declaring it to be in full accord with known scientific facts. Gladstone, however, knew something about the Bible and almost nothing about science, whereas Huxley had an enormous knowledge of both. The result was a crushing defeat for the elderly politician – 'not so much a battle, as a massacre'.

 In 1876, Huxley visited the United States. He told James Russell Lowell that he had 'a sort of dream of bringing the English speaking men of science together'. The main purpose of his visit was to speak at the opening of Johns Hopkins University. In his lecture he made the prediction that in 1976, at the second centenary of American Independence, the population of the United States would be about 200 million and that 'as population thickens in your great cities, and the pressure of want is felt . . . communist and socialist will claim to be heard'.

 Frank Harris, describing a photograph of Huxley, refers to the fact that it

> gives his features, but does not convey the challenge of the quick dark eyes or the pugnacity of the prominent cocked nose, or the determination of the heavy jaw, bushed eyebrows and clamped lips : – a fighter's face, if ever there was one, and the face of a Celt at that ; he reminded one always of Slavin, the Irish pugilist, though Slavin did not show so combative an air.

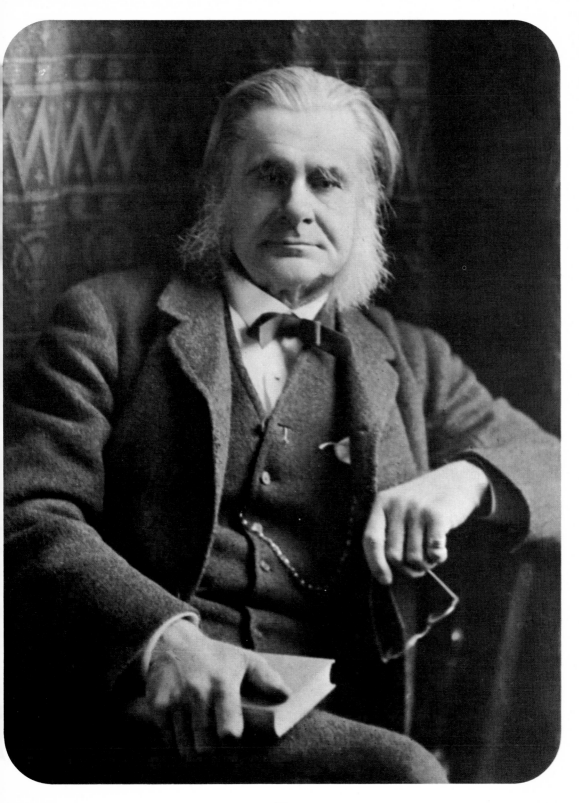

James Russell Lowell
1819 - 1891

Lowell was born and died in the same house in Cambridge, Massachussetts. After graduating from Harvard in 1838, he had published collections of poems before editing *The Pioneer*, which numbered among its contributors such eminent writers as Poe and Hawthorne. At the outbreak of the 1846 war with Mexico, Lowell denounced it in a satirical poem in the Yankee dialect; this he developed into an important collection of writings, *The Biglow Papers*, which is rated among his finest works. Also from this period come such popular poems as *The Vision of Sir Launfal* and *A Fable for Critics* – a series of witty portraits of American authors.

After a visit to Europe in 1851–52, Lowell returned to Harvard where, in 1855, he was appointed Professor of Modern Languages and Literature in succession to Longfellow – a post which he held until 1886. After 1857 he edited *Atlantic Monthly* and, with C. E. Norton, *North American Review*. His memorable *Commemoration Ode* of 1865 honoured the Harvard men who were killed in the Civil War. For many years he wrote prolifically both poetry and prose on a wide range of subjects, from essays on Shakespeare to anti-slavery poems.

Lowell's political interests and friendship with influential political figures led in 1877 to his being appointed American Ambassador to Spain; he is reputed to have declined the offer of a post in St Petersburg, remarking that he would like to visit Spain in order to see a play by Calderón. During his three-year term of office he was not called upon to make any significant diplomatic decisions, and his ambassadorship was unremarkable. Following this appointment, in 1880, and despite his prejudices against the English, he was given the post of Ambassador to the Court of St James's. Perhaps it was, as Henry James commented, that 'the true reward of an English style was to be sent to England'. Soon overcoming his opposition to English politics, he became deeply involved in English life, mixed with the leading literary men of London and lectured widely. Constantly in demand as a public speaker, a collection of his addresses made in England was published in 1886 as *Democracy*.

Returning to Harvard, Lowell devoted the rest of his life to his literary work, apparently astonishing Cambridge Society by donning the eccentrically British style of frock coat and high hat. He was always somewhat bizarre in appearance and would never wear a topcoat, even on the coldest day. On one occasion in London, at three o'clock in the morning in the middle of winter, wearing his ambassador's costume of thin pumps and silk stockings, he strolled home after a function at Buckingham Palace. Quite unaffected himself by the cold, his companion almost froze to death. His stocky build no doubt contributed to his hardiness – 'although small in stature', wrote a contemporary, 'he left you an impression of great dignity'. His mouth and eyes were said to betray 'a certain indecision . . . which helps us to recognize the author of the over-thoughtful poems and the exquisitely poetical essays', while his voice was noted for its 'crisp clearness', 'perfect modulation', 'clear enunciation' and 'exquisite accent'. His eyes of blue-grey were frequently remarked upon – not least by his many female admirers, one of whom called them 'the coaxin'est eyes'.

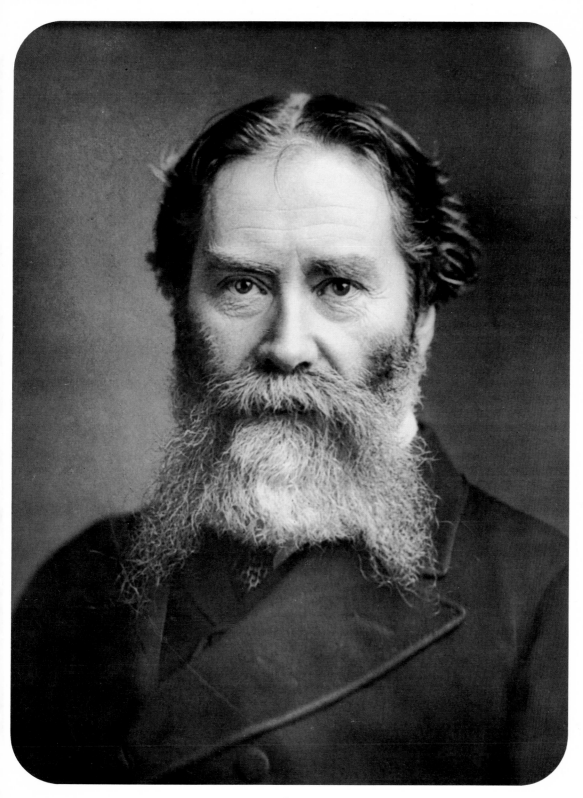

Ellen Thorneycroft Fowler
1860-1929

Ellen Thorneycroft Fowler, a popular novelist, was the daughter of Henry Hartley Fowler who, for his services in various government offices, was created First Viscount Wolverhampton in 1908. Ellen lived with her parents near Wolverhampton until 1903, when she married Alfred Felkin, an inspector of schools.

She began writing at the age of seven, when she compiled a long series of 'Poems on Current Events', and after 1888 had several volumes of her poems published. Encouraged by William Robertson Nicoll, an author and editor, she turned her attentions to novel writing and at his suggestion wrote a story dealing with Methodism, *Concerning Isabel Carnaby*. Published in 1898, it was an immediate success, was translated into French and German and printed in Braille, and remained a bestseller for several years. Although she occasionally wrote short stories, including contributions to Lady Randolph Churchill's *Anglo-Saxon Review*, her most notable literary achievements were undoubtedly as a novelist.

Although not a prolific writer – she published only half-a-dozen novels in the thirty remaining years of her life, including one, *Kate of Kate Hall*, written in collaboration with her husband – all her books achieved considerable sales and won her particular claim as one of Britain's outstanding *fin de siècle* authoresses. In 1899 and 1900 she was interviewed with such monotonous regularity by all the major literary and women's journals that her very technique of receiving interviewers became widely known. Seated in an armchair, she would ply her visitor with prodigious quantities of cakes and while he munched bombard him with a flow of words, 'bubbling with epigrams' and 'sparkling with wit' as one such victim was obliged to remark.

Like the productions of many other shooting stars of the Victorian era, the novels of Ellen Thorneycroft Fowler are not of enduring interest and are all now out of print. Even her biographer was compelled to conclude that:

> As a novelist she was a quiet and faithful chronicler of simple society. Her sense of character was firm and her dialogue lively. Her place in English fiction would have been higher had the construction of her novels been more vigorous and their range less narrow; but she was a solid writer in her quiet way.

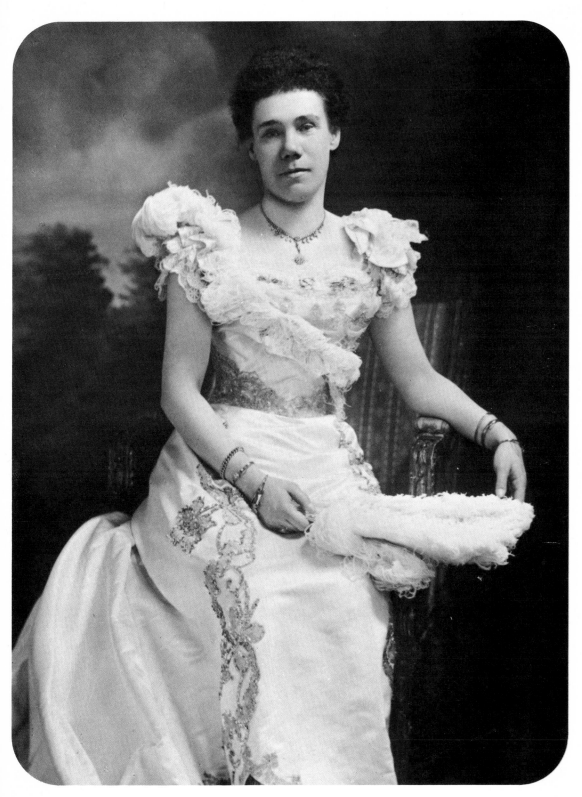

Henry Wadsworth Longfellow
1807 - 1882

Born in Portland, Maine, Longfellow is best known for his poem *Hiawatha*, published in 1855. Longfellow also produced prolific quantities of prose and poetry, much of which is now little read. He held the chair of Modern Languages at Harvard from 1836 to 1854, and lived at Cragie House, Cambridge, Mass., now a literary shrine. In his time he was widely acclaimed as a poet and scholar, and paid several visits to Europe and England. In 1842 he was the guest of Dickens, who later described him as 'a remarkably handsome and notable-looking man'.

His striking appearance inspired many other writers, including Blanche Roosevelt, who described the poet's eyes as

> clear, straightforward, almost proud, yet reassuring . . . In moments of lofty and inspired speech they have an eagle look, and the orbs deepen and flash . . . If sad, an infinite tenderness reposes in their depths, and if merry, they sparkle and bubble over with fun. In fact, before the poet speaks, those traitorous eyes have already betrayed his humor.

A London journalist saw him at the time of his award of a Doctorate of Letters at Cambridge, England, in 1868, and described how his

> long, white silken hair, and a beard of patriarchal length and whiteness, enclosed a young, fresh-coloured countenance, with fine-cut features and deep sunken eyes, overshadowed by massive black eyebrows. Looking at him, you had the feeling that his white head of hair and beard were a mask put on to conceal a young man's face : and that if the poet chose he could throw off the disguise and appear as a man in the very prime and bloom of youth.

During this visit, accompanied by a retinue comprising his son and daughter-in-law, his three daughters, two sisters, his brother and brother-in-law, he toured the English Lakes, breakfasted with Gladstone, was received by Queen Victoria at Windsor, and visited the Prince of Wales, Dickens, Tennyson and the Archbishop of Canterbury. On an earlier trip 33 years before, he had been introduced, by a letter from Emerson, to Carlyle. Now the Great American Man of Letters and the Great English Man of Letters were to meet again. Carlyle, however, apparently unimpressed with the way his guest had developed during the intervening years, wrote to a friend, '"Professor Longfellow" – Professor *Dull*fellow I rather found him, and was glad enough to see him go'. Emerson, on the other hand, retained his affection for Longfellow, and at the latter's funeral – a mere month before his own – described him as a 'sweet and beautiful soul'.

Andrew Lang
1844-1912

Andrew Lang, a Scottish writer best remembered for his poetry and retelling of folk tales for children, was an author of great versatility, covering in his books and journalism the fields of fiction, history, literary criticism, biography, theology and translations from Classical and French works.

As a child, Lang, an avid reader, had attempted to maximize his consumption of literature by simultaneously reading six books balanced on chairs. Of his early life little is recorded and he expressed a particular dislike for biographers. He did, however, leave certain autobiographical scraps among his tales, such as *The Gold of Fairnilee*, but dismissed them as 'only a lot of childish reminiscences'.

Continuing his education through reading almost every book he could lay his hands on, Lang became enormously knowledgeable on a host of subjects, excelling in Greek and Classical literature. After studying at Edinburgh University he attended Balliol College, Oxford, where he was taught by such eminent scholars as Matthew Arnold. Turning to authorship he compiled collections of folktales which are still in print, wrote works of outstanding scholarship on Greek literature and collaborated with H. Rider Haggard, author of *King Solomon's Mines*, on a popular novel, *The World's Desire*. Passionately interested in anthropology, comparative religion and folklore, he became one of the founders of the Folklore Society and later its Chairman. In his interpretations of mythology and folklore he entered into a long controversy with Max Müller and his followers. Müller attempted an explanation of the origin of folktales as the result of some linguistic accident and their spread as due to diffusion among Indo-European peoples. Lang, adopting an evolutionist standpoint, recognized similar myths among peoples as diverse as Australasians and Red Indians, and sought explanation in terms of common experience and psychology rather than through cultural affinity.

A friend, Alice King Stewart, wrote of him as follows:

> Andrew Lang was tall but inclined to stoop, with a rather slight figure. He was very active for his years. In my mind's eye I see him slouching easily along with his hands in his pockets, but I think that this attitude was to get a better view of things as he walked along. He was supposed not to have the use of one eye, and in the other he wore an unmounted monocle, which always seemed to be popping in and out and was only restrained from loss by a black elastic cord. Certainly with his one good eye he saw more than most people with two. His eyes were dark brown, matching his moustache. He had a fine intellectual head, sometimes held rather to one side when looking at objects, partly because of the blind eye. His hair never looked as if it had recently seen a barber, and the brindled locks, which Robert Louis Stevenson described, were white when I knew him.

William Wilkie Collins
1824-1889

Wilkie Collins, as he preferred to be called, was the son of a painter, William Collins, R.A., who directed his son into the tea trade. Finding this unconducive, he began writing as a hobby, and later left the tea business to study law. Although some of his early works received favourable critical reviews, his career as a writer really stems from his meeting in 1851 with Charles Dickens, who became his closest friend during the 19 years until Dickens' death. Dickens and Collins influenced each other's writing to a considerable degree, and Collins' major novels were first brought to the attention of a large audience as a result of their serialization in Dickens' journals, *Household Words* and *All the Year Round*. Collins' greatest work, which can be regarded as the first real English detective story, *The Moonstone*, published in 1868, was a bestseller and firmly established his reputation. In 1878, when this photograph was taken, he had severely damaged his eyesight by intensive writing, the products of which were the novel, *The Haunted Hotel*, and a progressively greater dependence on drugs.

Collins visited the United States in 1873–74 and gave readings from his works. By this time, he was becoming fat, stooped badly and had a wheezy chest. He was by no means a great public performer, such as Dickens had been, and friends tried to dissuade him from making the tour. Despite his obvious shortcomings, he sailed to New York where he found himself, to his delight, very much the centre of attention. The Press raved over his stylish suit (the cheapest readymade he could find in London) and his quaint accent (one Western newspaper referring, through a typographical error, to the remarkable 'flattening of his bowels'). Feted by his publishers, Harpers, and by Society in general, and demanding dry champagne wherever he went, as the one drink which did not affect his gout, he travelled and lectured – without either conspicuous success or disaster – appeared at the opening on Broadway of his play, *The New Magdalen*, and sailed home from Boston.

Collins directed that no biography of himself should ever be written, and those who have attempted to unravel his enigmatic personality have been hampered by the lack of documentary material – his voluminous correspondence with Dickens, for example, was destroyed at his request. Nuel Pharr Davis, in *The Life of Wilkie Collins*, describes this curious man thus:

> His head was disproportionately large, and the bones of his right temple projected in a congenital swelling. For him, he was accustomed to say, Nature had proved a bad artist; she had designed his forehead all out of drawing. He had tiny hands which he took care to keep soft and white, and feet so small that they would slip about inside a woman's shoe. The effect of these oddities was to make him look even shorter than he really was. But his build was in fact so slight and his weight so small that ordinary men could pick him up and carry him about like a child. Restless nervous energy made it hard for him to sit still. In most chairs his legs were too short to reach the floor; his habit was to grasp the seat between his knees with both hands, prop himself up straight, and rock continuously from side to side. When standing, because of his near-sightedness, he liked to walk up very close to anyone he talked to. Then, behind the small square thick lenses of his gold-rimmed spectacles, one became aware of bright, interested eyes filled with life and mischief.

Mark Twain
1835-1910

It was not until he was 31 that Mark Twain decided to become a writer. His previous ambitions, he explained in a letter to his brother, Orion, had been to be a preacher or a river pilot. The first he had discarded early in life because he did not have 'the necessary stock in trade – i.e. religion'. He had already realized the second when at the age of 18 he apprenticed himself to a riverman on the Mississippi, but the outbreak of the Civil War had brought his career to a halt. Now, he felt a call to literature 'of a low order – i.e. humorous'.

At 31 he had already accumulated in raw experience most of the material for his future books. Brought up on the west bank of the Mississippi, he had passed a lazy and slow-paced childhood by the river. His schooling was brief. At 13 he was apprenticed to a printer. He worked as a compositor, and later as a contributor, on the local paper, the *Hannibal Journal*, established by his brother. Unable to settle, at 17 he took to the road for the first time, an itinerant typesetter. Letters to the Keokuk *Daily Post* describing his travels began his career as a journalist, which was interrupted by four years as a steamboat pilot on the Mississippi, later used as the background for *Tom Sawyer, Life on the River* and *Huckleberry Finn*. For two weeks he became a Confederate irregular in the Civil War, but deserted and headed west to speculate unsuccessfully in mining and timber stock in Nevada and to prospect, equally unsuccessfully, for gold and silver.

Samuel Langhorne Clemens was his real name. Mark Twain was a pseudonym, the time-honoured call of the riverman sounding the shallows, and as Mark Twain he became famous throughout the United States for his witty newspaper articles and letters describing his travels around the country. Letters reporting his travels to Europe and the Holy Land in 1867 formed the basis for *Innocents Abroad*. He began to give public lectures, the salvation of many an impecunious writer in the 19th century, and discovered, after an initial seizure of stage fright, that he could dominate his audiences, making them laugh at his will.

In 1870 Mark Twain married and settled in Hartford, Connecticut. His peripatetic leanings were satisfied by frequent lecture tours through the United States and abroad. In 1870 he visited England where his name was already celebrated. He was sure that English Society would provide material for satire. Audiences along his lecture circuit observed with amazement his shuffling entry, his solemn and attenuated delivery and his colloquial frontier drawl, and roared with delight at his earthy and satirical humour. He in turn was startled at his reception. He was called upon by Charles Kingsley and Charles Reade, was invited to a ceremonial dinner attended by 'the brains of London' and presided over by the city's Sheriff; was invited to the Lord Mayor's banquet where the Chancellor of the country in wig and gown, his train and sword borne by a lackey, held his arm and told him how much he admired his work. 'I would rather live in England than America – which is treason,' he told his wife; he fell in love with the country. 'Rural England is too absolutely beautiful to be left out of doors,' he exclaimed, 'ought to be under a glass case'.

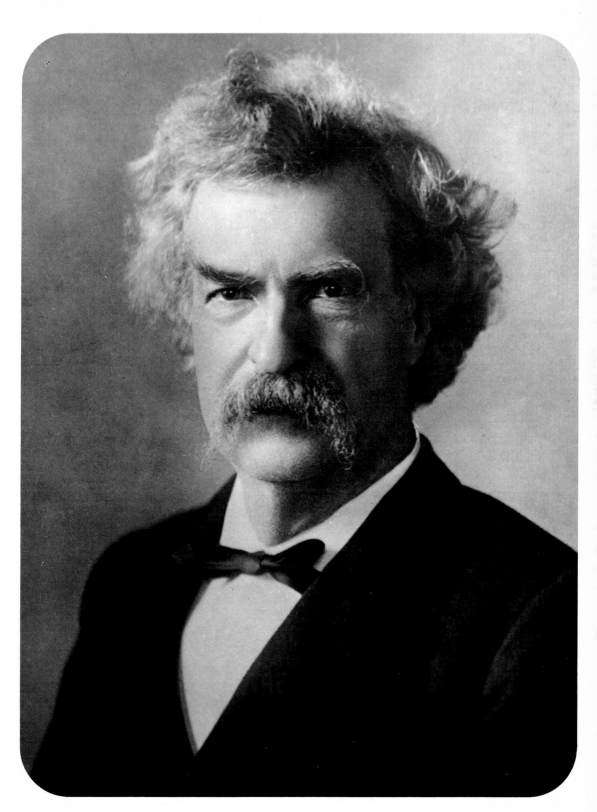

Matthew Arnold
1822-1888

Matthew Arnold was revered as one of the greatest poets, critics, educationalists and religious thinkers of his age. He was the son of Thomas Arnold, noted historian and headmaster of Rugby School. He held the Oxford poetry professorship for ten years, from 1857, although most of his best work was written before this period. His poetry is chiefly remarkable as a reaction against the romantic style which preceded him. His book, *Culture and Anarchy*, published in 1869, stands out as one of the classic political works of the 19th century, while his prolific studies of English and foreign educational systems, undertaken in his official capacity as an inspector of schools, influenced attitudes to British education for several decades. In his religious writings, he proposed the idea that the Bible should be read as inspired literature containing intense moral truths, and not as dogma – countering the increasing opposition to its teachings among scientists who saw in it tenets incompatible with their discoveries.

In 1883–84, Arnold lectured in the United States, but was critically received and widely misunderstood. A typical American newspaper article reported:

> 'He has harsh features, supercilious manner, parts his hair down the middle, wears a single eye-glass and ill-fitting clothes.'

Indeed, he struck many of his contemporaries as 'affecting a combination of foppishness and Olympian grandeur'. G. W. E. Russell, on the other hand, thought him 'a man of the world entirely free from worldliness and a man of letters without the faintest trace of pedantry'. In *Contemporary Portraits*, Frank Harris provided a good description of Arnold's appearance at about the time this photograph was taken (1883):

> 'A tall man, who in spite of slight frame and square shoulders, had at least in later life something of the scholar's stoop. A rather long, pale, brooding face; hair parted in the middle over a head a little too flat for thoroughgoing belief; a long well-shaped nose – a good rudder – a strong but not bony chin; altogether a well balanced face, lighted by pale greyish thoughtful eyes. Two side whiskers lent their possessor the air of a butler of a good house, the shaven lip allowed one to see the sinuous sensitive mouth of the orator or poet.'

Walter Pater
1839 - 1894

In 1873 Walter Pater published a collection of nine essays – analyses of art, of personalities, of stories and poetry – all of which had appeared in various journals at intervals during the preceding years. The book was innocuously entitled *Studies in the History of the Renaissance*. The publication struck England's intellectual community with the force of a thunderbolt.

Its author was a Fellow of Brasenose College, Oxford, a discreet and conventional academic. Spoken of as the man with no private life, his existence was markedly austere, his cell-like rooms and regular habits betraying his sympathy with the monastic way of life. He dressed conservatively, his apple-green tie the only visible clue to an inner rebellion against convention.

One passage in the Conclusion to the *Studies*, his first published work, disturbed the life of Victorian Oxford, seeming, as it did, to advocate a kind of pagan aestheticism, a spontaneous hedonism. In it, Pater expressed the belief that personal experience is the goal of life and that any theory, idea or system which limits the experience of the individual has no claim upon him.

The idea destroyed the reputation of its author almost before the book had established his name as a literary critic. In 1873 he was forced from obscurity by the condemnation of his former tutor, the Master of Balliol. His work attracted the satire of an undergraduate in a piece which linked Pater's name with that of Oscar Wilde, one of his students who declared his admiration for him. There is evidence that as a young man Pater was attracted towards homosexuality, but he was the epitome of discretion and there is nothing to say that he ever indulged in homosexual practices. A tale survives that once, when asked to give his verdict upon the examination results of an undergraduate named Sanctuary, he suggested that perhaps he should be passed, because his name was so pleasing.

In 1874 Pater deleted the passage which had caused so much consternation from the second edition of his book, and modified it for the third. For 12 years he maintained a literary discretion, but in 1885 his philosophical romance, *Marius the Epicurean*, was received with interest and *Imaginary Portraits*, followed in 1889 by *Appreciations*, firmly established his name as a literary critic.

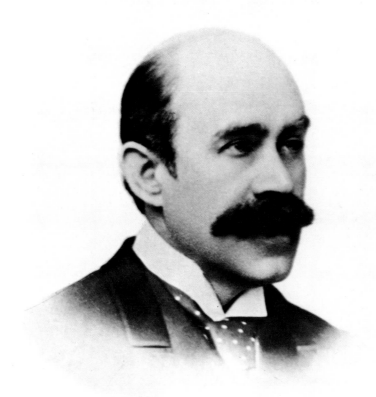

Oscar Wilde
1854 - 1900

The complicated collection of names with which the great wit of the Victorian era was endowed at his christening leave no doubt as to the racial origins of Oscar Fingal O'Flahertie Wills Wilde. He was the son of Ireland's most eminent ear and eye surgeon who was also an amateur archaeologist. His mother was a revolutionary and poet.

The few photographs of Oscar Wilde which survive from his undergraduate days or earlier show him to have been a tweedy youth, tall, with a friendly and good-natured expression. At Oxford he sported check suits and a bowler hat strictly in accordance with the convention of the day.

When he was 27 and a struggling writer just four years down from Oxford, Wilde was offered the opportunity to accompany the D'Oyly Carte Opera Company on an American tour. The opera to be staged was Gilbert and Sullivan's *Patience*, which satirized the Aesthetes and the Pre-Raphaelites – Rossetti in particular. Wilde's role was part of a Victorian publicity stunt; to demonstrate to the unwitting Americans what the English Aesthetic Movement and *Patience* were about, he was to give a series of lectures, exaggerating the dress and acting the part of an Aesthete. He was ideal for the task. A disciple of Ruskin and Walter Pater, his tutor at Oxford, he was already something of an aesthetic poseur, and as such had been satirized in *Punch*. The influence of Swinburne, Rossetti and Keats were apparent in his *Poems*, which he published in 1881 at his own expense.

He arrived in New York proclaiming that he had 'nothing but his genius to declare'. Wearing a velvet jacket, lavender knee breeches and black silk stockings, with hair down to his shoulders, yet lecturing eloquently and seriously, he was an immense success. He was credited and caricatured in the press, feted and entertained by Society. His lecture tour, on which he exhorted Americans to 'love art for art's sake', provoked more attention and comment than the opera he had come to publicize. 'Great success here: nothing like it since Dickens, they tell me,' he wrote home. He sold an idea for a play, met Oliver Wendell Holmes, Longfellow and Walt Whitman. He returned to England with something of a reputation, one thousand pounds and a singular fur coat which accompanied him through his successes, acquired fame with him, and disappeared on his imprisonment.

Most of Wilde's important literary work was written during the final decade of his life. He was a remarkably versatile writer. He wrote reviews for the *Pall Mall Gazette* and, for a brief two-year period, edited the *Woman's World* magazine which he competently transformed from a paper which dealt 'not merely with what women wear, but with what they think, and what they feel'. His gift for romantic allegory was revealed in *The Happy Prince and Other Tales* and *Lord Arthur Savile's Crime and Other Stories*. His greatest successes were his Society comedies in which he gave full reign to his natural wit and his love of the paradoxical to produce a revitalized form of English drama which subtly exposed the hypocrisies of the age.

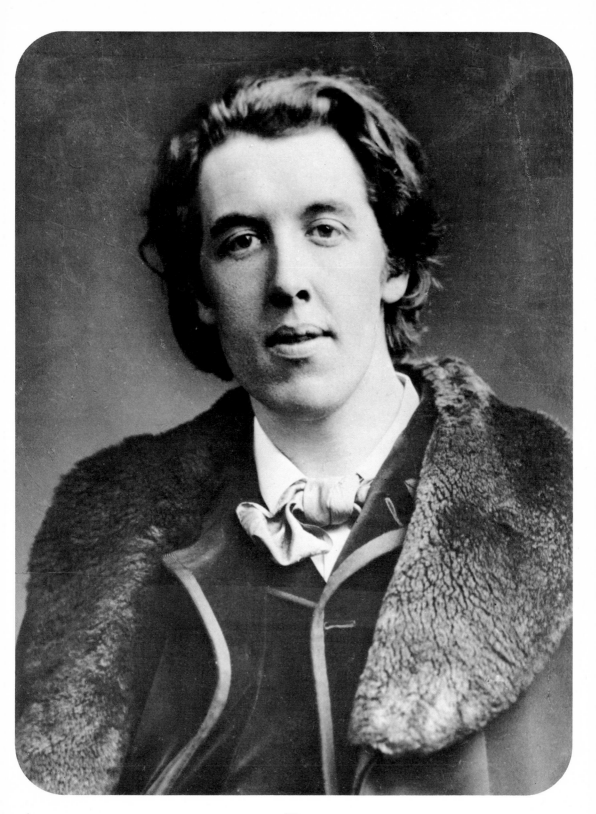

John Ruskin
1819 - 1900

By 1882, the year this photograph was taken, John Ruskin, philosopher, writer, critic and artist, was almost an anachronism in Victorian society. Born in the same year as Victoria herself, he more than anyone else had publicized the doctrines and influenced the aesthetic senses of her time. A decade after *Modern Painters*, his most important collection of writings, had been completed, he was created Oxford's first Slade Professor of Fine Art. In 1879, bouts of insanity forced him to resign his professorship.

'I went wild again for three weeks or so, and have only just come to myself – if this be myself, and not the one that lives in dreams,' wrote Ruskin to his old American friend, Charles Eliot Norton, on 24th March 1881. The debilitating brain fevers which had interrupted his work since his mother's death in 1871 had turned him into an old man, a transformation which Norton noted in 1883: 'I had left him in 1873 a man in vigorous middle life, young for his years, erect in figure, alert in action, full of vitality, with smooth face and untired eyes. I found him an old man, with look even older than his years, with bent form, with the beard of a patriarch, with habitual expression of weariness, with the general air and gait of old age'.

Ruskin's admiring and sympathetic physician, Sir William Gull, recommended a tour of the Continent. Early in August he set out with a companion on another journey, visiting his old haunts in France *en route* for Italy.

In Tuscany in 1882 he discovered Francesca Alexander, a young American painter. She had grown up in a remote Italian village where her father, a talented and well-connected portrait painter from Boston, taught her to paint. Unaffected by convention in art, she had developed her own style. Ruskin was captivated by her. In London, to the incomprehension of the Victorian artistic establishment, he lectured on her work, and distributed her drawings.

Since Ruskin's quarrels with Rossetti in the 1860s, he had become estranged from the Pre-Raphaelites with whom he had been closely connected. In 1882 Rossetti died, and Ruskin paid tribute to his old friend: 'I believe his name should be placed first in the list of men, within my own range of knowledge, who have raised and changed the spirit of modern Art: raised, in absolute attainment; changed, in direction of temper'.

Invigorated by his Continental journey, his nightmares temporarily in abeyance, Ruskin felt better in 1882. He returned to Oxford, to the students who attended his lectures to smile at his eccentricities.

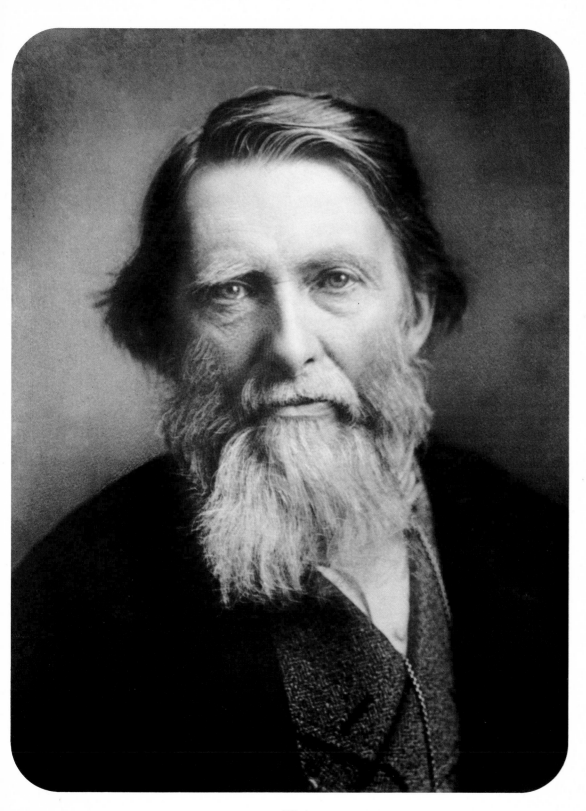

Algernon Swinburne
1837 -1909

To the Victorian mind, the intoxicating lyricism of Swinburne's poetry was wickedly deceptive. A master of prosody, he shocked his contemporaries with rhythmic, voluptuous verses which too often spoke of the pleasure to be found in pain, and of diverse and perverse forms of love. The mellifluous, insistently rhythmic stanzas lulled the mind into blissful unawareness of their message.

Benjamin Jowett, his celebrated tutor at Oxford, said that Swinburne bore 'an extreme and almost unintelligible unlikeness to ourselves'. His eccentricities were noted by others from a very early age. At Eton he was known as 'Mad Swinburne'; he was easily excitable, and would compulsively vibrate his hands, jerk his arms and legs, and twitch his feet, while his face would take on an expression of rapture. A doctor diagnosed 'an excess of electric vitality'. He was a peculiar, elfin creature. His cousin recalled that at Eton he was 'strangely tiny. His limbs were small and delicate; and his sloping shoulders looked far too weak to carry his great head, the size of which was exaggerated by the touzled mass of red hair standing almost at right angles to it'. He left Eton at 16, his impressionable mind indelibly marked with memories of frequent whippings he had received while there.

At Oxford, Swinburne became a member of the Old Mortality Society, which numbered Walter Pater, J. A. Symonds and Lord Bryce among its members, and was so called because not one of them was in sound health. The Society held literary readings, and its members concerned themselves with the cause of Italian liberty. At Oxford he came under the influence of the Pre-Raphaelites, and later was installed, together with other red-haired people, a motley collection of armadillos, peacocks, marmots, racoons, wombats, kangaroos and George Meredith, in Rossetti's house in Chelsea. In 1865 his overtly pagan *Atalanta in Calydon* was published, followed by *Poems and Ballads* in 1866, which was violently attacked for its carnality. Richard Monckton Milnes, one of the first to recognize Swinburne's genius, introduced him to the writings of the Marquis de Sade, at which, Swinburne said, he never laughed so much in his life. These writings, together with the influence of his cousin, Mary Leith, with whom Swinburne grew up, exacerbated his obsession with algolagnia, sexually-inspired flagellation. Thought to have been the original Dolores or Faustine, hard heroines of his writings, Mary Leith actively encouraged his aberration.

Never strong, Swinburne's excessive alcoholism, the epileptiform fits to which he was subject, and his masochistic indulgences, gradually undermined his health. When he was 42 he suffered complete collapse, and was rescued by Watts-Dunton, a fellow-poet, who persuaded Swinburne to live with him at The Pines, his house in Putney. There, under Watts-Dunton's guardianship, Swinburne was encouraged to observe a strict regimen and to devote his time to writing. During a period of 30 years Swinburne published 23 volumes of poems, plays and prose writings.

William Morris
1834 - 1896

Through the multifarious and dilettante activities of his life, William Morris, poet, painter, craftsman and aesthete, determined to raise the aesthetic consciousness of the 19th-century British public, and to introduce beauty into the grim, industrial surroundings borne by many of them.

He came from a well-off family, and went from public school to Oxford where, strongly influenced by the Oxford Movement, he determined to take Anglican Orders. However, struck 'with the force of a revelation' by Ruskin's probings into the social and moral foundations of architecture, Morris became aware of his own interest in the subject. He went to work in the Oxford office of G. E. Street, a Gothic Revivalist architect, where he met and befriended Philip Webb, Street's assistant. A holiday in France confirmed Morris' enchantment with all things medieval. He was inspired by the Pre-Raphaelites, in whose manifesto, the *Oxford and Cambridge Magazine*, which he financed, his first poems were published. Under Rossetti's influence he decided to dedicate himself to art, and he joined a group who were decorating the Oxford Union with scenes from Malory's *Morte d'Arthur*.

For a while he lived in London with Burne-Jones and designed and built medieval-style furniture. With Philip Webb he designed the Red House at Bexleyheath, in a style of architecture novel for its red brick and tile simplicity. It was in the search for suitable furnishings that, with Ford Madox Brown, Rossetti, Webb and Burne-Jones, he founded in 1861 an association of 'Fine Art Workmen in Painting, Carving, Furniture and the Metals'. New churches provided a market for their creations. Morris experimented with vegetable dyes and designed wallpapers, chintzes, carpets, tapestries and furnishing materials.

Through his lectures, which he began in 1877, and continued to give for the rest of his life, Morris propagated his ideas. To young architects, he tirelessly preached a gospel of beauty for its own sake, a plea for aesthetic considerations in the design of common objects. He pleaded for the preservation and informed restoration of old buildings, for a revolution in architecture. He thought that art should be created 'by the people, for the people, as a joy to the maker and user'. In 1883 he became a Socialist and toured the industrial provinces to disseminate his new creed. His personal brand of Marxism was expounded in his book, *News from Nowhere*, a masterpiece of Utopian fiction. In his lectures he argued for the return of the artisan and for the reawakening of interest in handicrafts.

In 1878, Morris launched himself into his last consuming interest – the Kelmscott Press, on which he printed 53 titles in 8 years. His most magnificent work, a beautifully decorated copy of Chaucer, occupied the last five years of his life.

Edward Burne-Jones
1833 - 1898

Burne-Jones intended originally to enter the Church, but his friendship with William Morris and admiration for Dante Gabriel Rossetti led him into a career as a painter – in many respects the most influential of the 19th century. As a partner in Morris & Co. he was chiefly employed as a designer of stained glass and tapestries, while as a painter his main preoccupation was with representations of Arthurian scenes, allegories and myths and legends.

Georgiana Macdonald, later Burne-Jones' wife, left a description of an early meeting with her husband:

> Rather tall and very thin, though not especially slender, straightly built with wide shoulders. Extremely pale he was, with the paleness that belongs to fair people, and he looked delicate but not ill. His hair was perfectly straight, and of a colourless kind. His eyes were light grey (if their colour could be described in words), and the space that their setting took up under his brow was extraordinary: the nose, quite right in proportion, but very individual in outline, and a mouth large and well-moulded, the lips meeting with absolute sweetness and repose. The shape of his head was domed, and noticeable for its even balance; his forehead, wide and rather high, was smooth and calm, and the line of the brow over the eyes was a fine one. From the eyes themselves power simply radiated, and as he talked and listened, if anything moved him, not only his eyes but his whole face seemed lit up from within.

At the time this photograph was taken, in about 1890, his self-consciousness is still in evidence, despite his now acknowledged role as one of England's greatest painters. By the 1890s, Burne-Jones had reached the peak of his ability and particularly through exhibitions of his work in the Grosvenor Gallery, London, and elsewhere, he had attracted a wide following numbering among them such admirers as Gladstone, Ellen Terry, Oscar Wilde, Paderewski and Sullivan. For Henry Irving he designed costumes and sets, and for Balfour produced ten fine medieval subjects as decorations for his music room. In his later years he worked on such masterpieces as *Arthur in Avalon*, now in Puerto Rico – unfinished even after 17 years' endeavour – and the mosaic decoration of the American Church in Rome. In 1894 he was awarded a baronetcy – an honour which with typical diffidence he received reluctantly.

George Du Maurier
1834 - 1896

The talents of George Du Maurier, one of the foremost graphic artists of the 19th century, lay, in his own words, in 'Social Pictorial Satire'. His *Legend of Camelot*, published in *Punch* in 1866 and in book form in 1898, lampooned the Pre-Raphaelite movement, and his cartoons, which appeared for many years in *Punch*, satirically portray many of the social idiosyncrasies of his age, from its class structure to the Aesthetic Movement. His technical virtuosity is all the more remarkable since in his youth he lost the sight of one eye.

Born in Paris, he studied chemistry in London and art in Antwerp, finally settling in London where he spent almost 40 highly productive years in illustrating periodicals and books, including his own three novels, *Peter Ibbetson*, the semi-autobiographical *Trilby* and *The Martian*.

An engaging personality, he is said to have used his similarity of appearance to Alma-Tadema to comic advantage. When women told him how much they admired his paintings of Roman subjects, he would adopt a thick Dutch accent and invite them to one of Tadema's famous 'At Homes'. No-one knows how many total strangers Tadema found himself entertaining as a result of this imposture.

Ruskin praised Du Maurier, comparing him with Holbein. He was similarly lauded by such contemporaries as Henry James. In 1880, Du Maurier supplied the illustrations to Henry James' *Washington Square*. This was the beginning of a rewarding friendship between the English artist and the American writer. The French writer, Jean Jusserand, who knew them both, remarked that 'James and Du Maurier offered a lively contrast. That best delineator of British foibles, whims and fads, a sharp-eyed critic but with no bitterness in his criticism, was of French origin . . . Like Molière, this judge of manners who, every week, exhilarated countless people, was of melancholy disposition, his smile was tinged with sadness'. Through James, Du Maurier met James Russell Lowell and their families spent summer holidays together in Whitby, Yorkshire. Upon his return to the United States in 1885, Lowell wrote to Du Maurier of his admiration for his work: 'They are the main consolation of my old age. I strain my eyes for them as men on a raft for a sail.' Just before his death, Lowell wrote to James, asking him to tell Du Maurier 'that my chief solace (since I have been well enough) has been in looking over old *Punches* and enjoying him in them'.

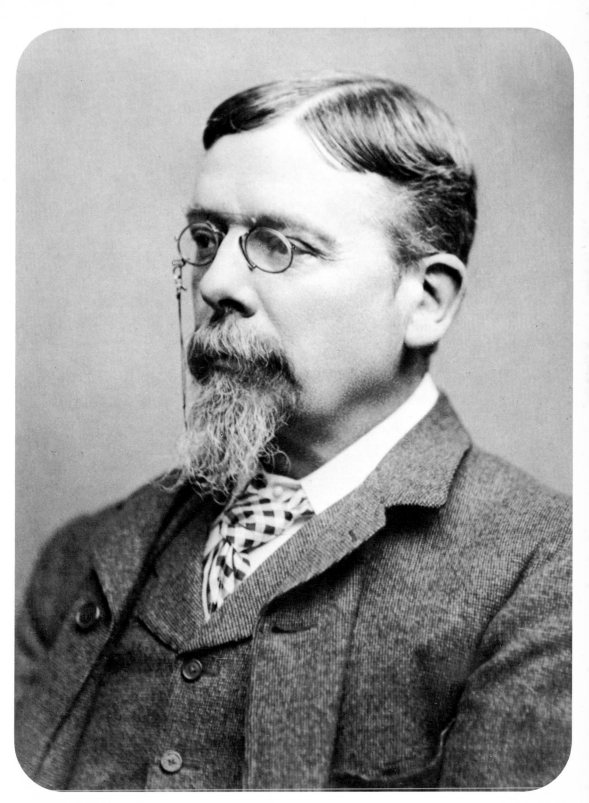

Lawrence Alma-Tadema
1836 - 1912

One of the most successful of all 19th-century painters, Alma-Tadema's art is so typical of the late Victorian period that it was among the most despised and neglected during the years from his death until its recent reappraisal when it once again began to command high prices at auction. Of Dutch birth, he studied in Antwerp and Paris before settling in London, where he worked from 1870 until his death. There he perfected a unique style of painting, occasionally undertaking portraits, but most typically depicting in the minutest detail and with supreme technical skill scenes of daily middle- and upper-class life in ancient Rome. The enormous popularity of his paintings and engraved versions of them, despite their remorseless similarity of theme – Romans going out, Romans coming home, Romans courting their loved ones and Romans at dinner – and the extremely high prices they commanded (£10,000 for a single canvas, when for the same sum one might have had half a dozen first-rate Impressionists), can be explained by the fact that Alma-Tadema's Romans were really only thinly disguised 'Victorians in Togas'; he was giving his wealthy contemporaries themselves, with their most cherished sentiments and virtues, but with the stamp of Classical respectability.

As a result of this single-minded exploitation, Alma-Tadema grew very rich, built himself a veritable palace in London's St John's Wood as a monument to his success, and surrounded himself not only with fellow artists, but also with notable patrons and friends, numbering among them leading members of British Society and Royalty. It was not only his position as a painter, but his warm personality which won him so pre-eminent a status among artists, as Julian Hawthorne, a writer, described after his first meeting with Alma-Tadema:

> '. . . a rather short, broad, blond personage stood before us: a broad forehead, pale grey eyes with eyeglasses, a big humorous mouth hardly hidden by a thin, short, yellow beard. His front face was blunt, jolly and unremarkable; but his profile was fine as an antique cameo . . . the vitality and energy of his aspect and movements and the volume of his voice were stunning . . . his great, delighted laugh constantly recurred, resounding through the beautiful rooms from the midst of the group that always gathered about him; he made ordinary people appear anaemic and ineffectual. Withal, he was civilised and fine to the bone, and his utmost boisterousness never struck a wrong note. He won you at first accost as a superb human creature, and by degrees you began to see his pictures in him.'

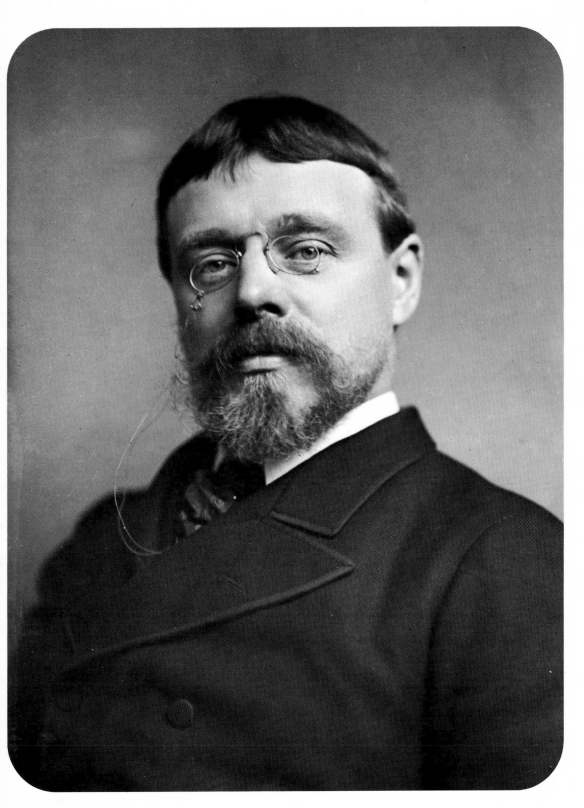

Lady Annesley
1870 - 1941

The daughter of William Armitage Moore of Arnmore, County Cavan in Ireland, Priscilla Cecelia became the wife of Hugh, the fifth Earl Annesley, in 1892. Hugh, then aged over 60, had followed a distinguished military career as a Lieutenant-Colonel in the Scots Guards, and had been wounded in the Kaffir War and at the Battle of the Alma in the Crimea. He served as Member of Parliament for Cavan from 1857 to 1874, married first in 1877 and was widowed in 1891. A wealthy landowner controlling 52,000 acres, his young bride was his cousin and a member of the family which by tradition managed his estates. Regarded as one of the great beauties of the time, Lady Annesley became a leading Society hostess and was well remembered for her hospitality at the Annesley residence at Castlewellan. The house was noted for its magnificent gardens, a particular interest of the Earl who in 1903 published *Beautiful and Rare Trees and Plants*. He died in 1908, she in 1941 at Bath.

Photographed here at the time of her marriage to Lord Annesley, Priscilla typifies the ideal of female elegance of the late Victorian period. Her dress, her hairstyle and her pose are the products of the styles made popular by the Aesthetic Movement, the neo-classical paintings of such artists as Alma-Tadema and Albert Moore, and the Art Nouveau mode promoted especially by the London firm of Liberty & Co.

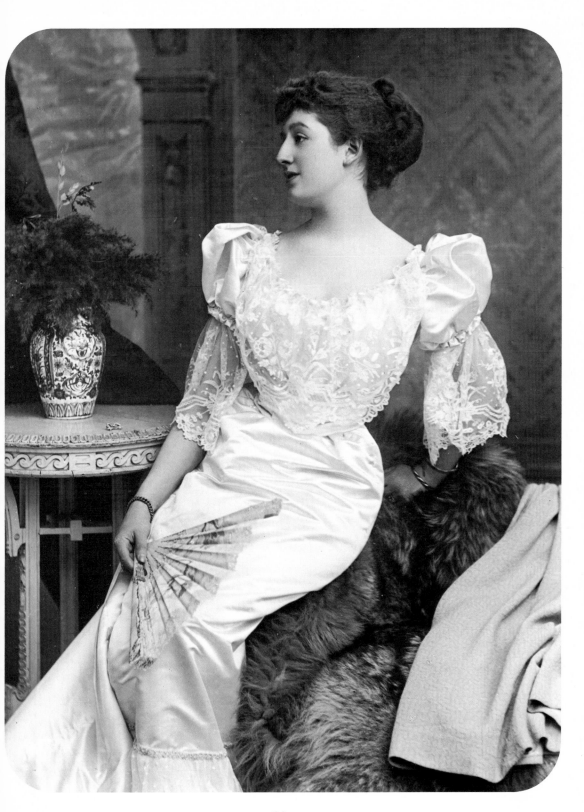

King Cetshwayo
c. 1826 - 1884

The last Zulu king, Cetshwayo, or Cetewayo, was recognized as ruler of his people by the British in South Africa and, after a tribal ceremony, was crowned by the British Secretary for Native Affairs, Theophilus Shepstone. When the Zulu War broke out, however, Cetshwayo led his army against the British, wiping out an entire regiment in a surprise attack at Isandhlwana on 22nd January 1879. By August, however, the British had the upper hand. Cetshwayo was captured and imprisoned, and his land was divided between 13 chiefs. In 1882, having successfully pleaded to be allowed to state his case (to be allowed to return to Zululand) to Queen Victoria, he was taken to England where his noble and imposing appearance, and the many rumours concerning his sexual and dietary habits, made him the centre of attraction throughout his stay. His mobbing during his visit to Bassano's studio to have this photograph taken was described by Lady Wolseley in a letter of 13th August 1882:

> Fancy my waiting in 'Givry's' balcony in Bond Street for an hour to see Cetawayo (sic) come out of Bassano's? The crowd was so great I was afraid to venture into the street, or I should not have waited so long. I saw him capitally. He *rolled* majestically across the pavement with a good deal of 'side on'. A boy in the crowd said rather wisely, "His name ain't 'Getawayo' for he can't Getaway", which was quite true. They had to send for more police and hustle him off through Benson's shop, to dodge the mob at Bassano's door.

In practice, the division of Zululand was found to be impossible, and Cetshwayo was reinstated as king in January 1883. Rival chiefs, however, resenting his power rebelled against him and he was compelled to seek the protection of the British at Eshowe. There he died suddenly – apparently of a heart attack, although the possibility of his being poisoned cannot be ruled out. His grave is still venerated as a shrine by the Zulu people, to whom he undoubtedly restored prestige as a nation.

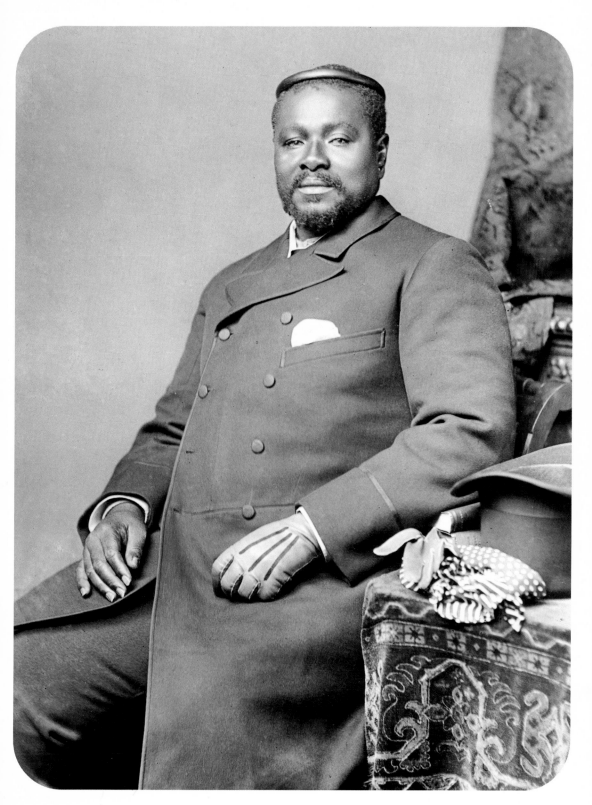

The Rajah of Cochin
1835 - 1888

Photographed in 1876, during a state visit to London, Rama Varma, the Rajah of Cochin, succeeded in 1864 as the ruler of a small state in south-west India, part of the ancient kingdom of Kerala. The Rajahs, of pure Kshatriya blood, claimed descent from a 9th-century king, Cherman Perumal, who renounced his kingdom and became a Muslim, dying on a pilgrimage to Arabia. After a period of Portuguese and Dutch settlement, in 1776 Cochin was conquered by Hyder Ali, and in 1790 ceded by his son, Tippoo, to the British.

Prior to the arrival of the British, the Rajah held despotic power over the lives of his subjects and kept large numbers of slaves. The East India Company and later the British Government, in return for substantial annual payments, undertook the military protection of Cochin, but completely removed the power of the Rajah who became no more than a nominal ruler. Administrative affairs were handled by appointed ministers, or Diwans, while the Rajah, according to a contemporary visitor, left with virtually no state responsibilities, passed his days in prayer, ritual bathing and eating a succession of vegetable curries. Rama Varma succeeded his uncle, Ravi Varma, under a curious rule whereby the heir apparent, or Elliah Rajah, was normally the eldest son of the ruler's younger brother, or if he had no brothers, the eldest son of his most senior sister, the Ranee. He himself was prohibited from marriage. At the palace at Tripuithura, he received lessons from Brahmans and from English tutors who, as a distinct policy, inculcated in him the belief that the British were members of a higher caste than himself, that he could never regain independence, that any attempt at a coup to overthrow his masters was pointless, and that only through cooperation with the British could he achieve prosperity for his people who, at this time, numbered about 600,000.

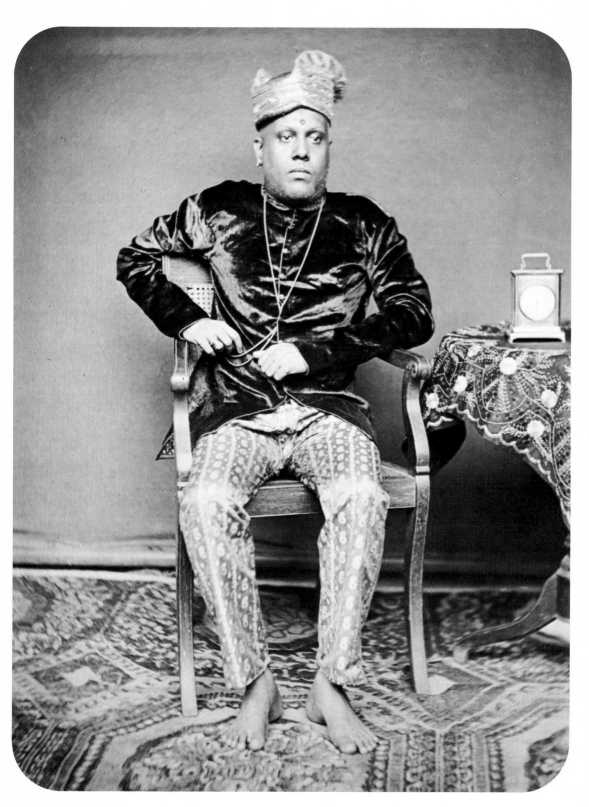

Queen Victoria
1819 - 1901

'Today is the day on which I have reigned longer, by a day, than any English sovereign,' the Queen recorded in her diary on 23rd September 1896. In her Diamond Jubilee year, when this photograph was taken, she was 78 years old. George III had held the throne for 59 years and 96 days; among her contemporaries, only Franz Josef, Emperor of Austria, had reigned longer.

Queen of the United Kingdom of Great Britain and Ireland and Empress of India, after 60 years as monarch Victoria was at the height of her prestige and popularity. Britain was prospering; the rapid extension of the boundaries of her young Empire was the theme emphasized in the celebrations of her Diamond Jubilee.

On Sunday 20th June, the anniversary of her Accession, a Jubilee service was held at eleven o'clock at every church, chapel or synagogue, in the country. At the special family Thanksgiving in St George's Chapel, Windsor, the words of Bishop How's Jubilee Hymn were sung to the music of Sir Arthur Sullivan.

On the following day a splendid chocolate brown and white royal train fitted with satinwood, silk and lace carried England's venerable Lady Ruler (so described by Alfred Harmsworth, the newspaper magnate) to London, an imperial capital decorated at a cost of a quarter of a million pounds. At night the city radiated the glow from millions of tiny gas lights which on Accession Day, in 1837, had been an innovation, and the brazen glare of the new electric light. Every royal residence was crowded with Prime Ministers, delegates and representatives of the colonies and dependencies, together with their entourages, in preparation for the public ceremonies of 22nd June.

At the start of a gloriously sunny day, the Queen pressed an electric button to send her Jubilee Message humming around the Empire: 'From my heart I thank my beloved people. May God bless them!' A military salute in Hyde Park announced the start of the magnificent procession, headed by the tallest man in the British Army, Captain Ames of the 2nd Life Guards, who stood an imposing six feet eight inches. The monarch, accompanied by her family, colonial officials and envoys and regiment upon regiment of gorgeously-vested imperial troops, made a six-mile circuit of the metropolis, crossing London Bridge to the poor districts south of the Thames, and paused for a short service and a brief but hazily unsuccessful cinematographic record of the occasion on the steps of St Paul's. 'No one ever, I believe, has met with such an ovation as was given to me, passing through those six miles of streets . . .' wrote Victoria, 'the crowds were quite indescribable, and their enthusiasm truly marvellous and deeply touching. The cheering was quite deafening, and every face seemed to be filled with real joy.'

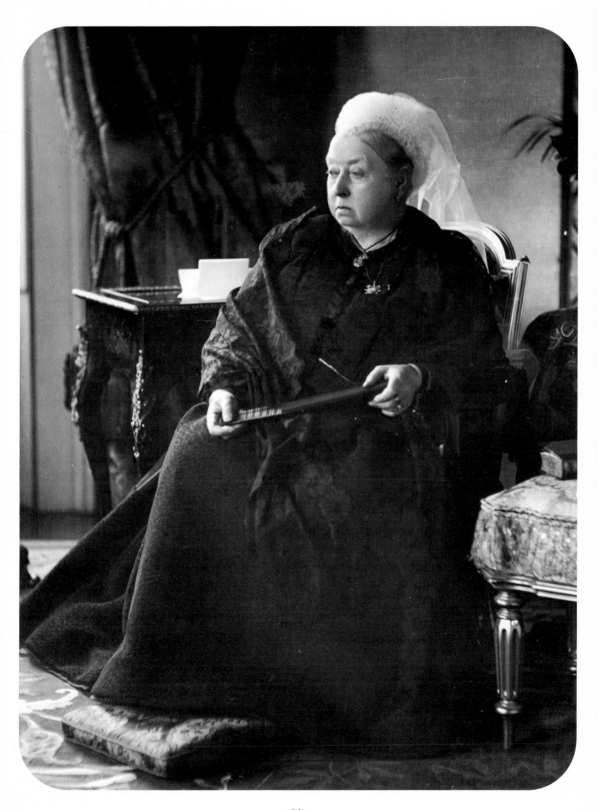

Queen Victoria and Princess Margaret of Connaught

A woman of anxious temperament, Queen Victoria was inclined to worry a great deal over the problems of her extensive family. Their births, illnesses, deaths, quarrels and estrangements all affected her profoundly. 'The very large family with their increasing families & interests, is an immense difficulty and – I must add – burthen to me!', she wrote to the Princess Royal in 1876. 'Without a Husband and father the labour of satisfying all (which is impossible—), and of being just & fair & kind – and yet keeping often quiet which is what I require so much – is quite fearful !'

Unable, like many women, to overlook her children's faults, Victoria had been in many ways a hard and selfish mother. Approaching her sixties, she made a conscious effort to adopt a more tolerant attitude towards them. When, in 1877, her third and favourite son Arthur, Duke of Connaught, announced his intention to marry Princess Louise Margaret, daughter of Prince Frederick Charles of Prussia, she made little objection, though she had played no part in the match. The princess came from a broken home, and Victoria felt that her son should first have considered alternatives. The Prince visited Frogmore alone with his fiancée and the Queen, surprisingly, made no comment, though her views on such improprietous conduct were well known. 'I think there is a great want of propriety & delicacy as well as of dutifulness in at once treating your Bridegroom as though (except in one point) – he were your Husband.' Her new policy of toleration prevailed though she thought that 'young people are getting very American, I fear in their Lives and ways'.

Amid greater pomp and ceremony than had distinguished royal weddings since the marriage of the Princess Royal in 1858, the couple were married at St George's Chapel, Windsor, on 13th March 1879. The year, her sixtieth and the year her first great-grandchild was born, was significant in Victoria's life, for it marked the break from the seclusion and isolation of her widowhood since 1861. At the wedding she wore a court train for the first time since 1861. She also wore a long white veil and the Koh-i-Noor diamond. Privately Victoria expressed a few misgivings on the subject of matrimony: 'A marriage is no amusement but a solemn fact, and generally a sad one,' she wrote to her eldest daughter.

Her fears were unfounded for this marriage did not prove an unhappy one. In 1882 a daughter was born, 'Daisy', Princess Margaret of Connaught, and the future Crown Princess of Sweden who, aged three, appears in this photograph with her proud grandmother.

With her 36 grandchildren, Victoria was indulgent and quick to perceive their virtues. Little Daisy was uproariously naughty, but her disobedience went unpunished because she was 'so funny'. As Victoria grew older, her family became less of a burden, each birthday made into a joyful occasion by crowds of little grandchildren and great-grandchildren at a great family reunion. In the morning they greeted her with shouts of 'Many happy returns, Gangan', and in the evening entertained her with their traditional play called *Grandmother's Birthday*.

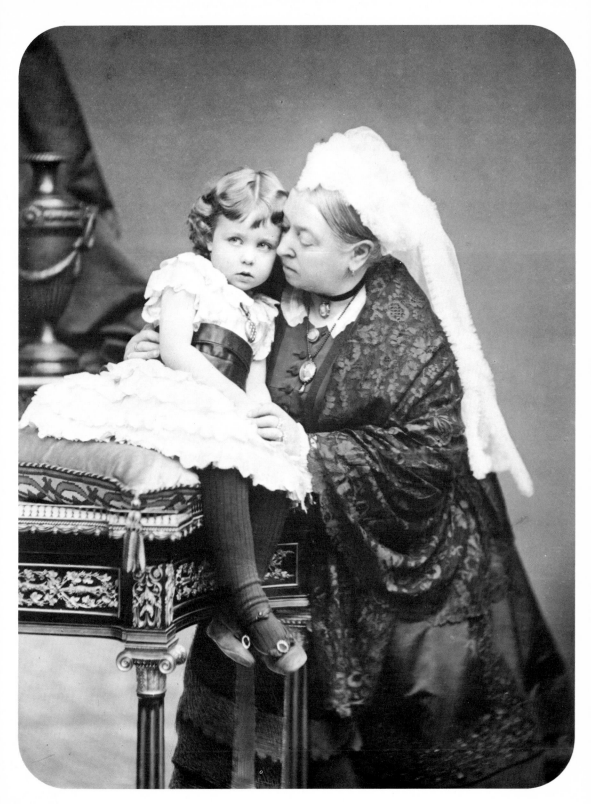

Prince Arthur
Duke of Connaught
1850 - 1942

The third son and seventh child of Queen Victoria, Arthur William Patrick Albert was born at Buckingham Palace on 1st May 1850, the 81st birthday of his god-father, the Duke of Wellington, from whom he took his first name. Ever a woman given to extremes of devotion or dislike, Victoria soon came to regard him as her favourite child. 'Darling Arthur', he became, and she would write of how much she 'adored our little Arthur from the day of his birth. He has never given us a day's sorrow or trouble . . . but has ever been like a ray of sunshine in the house.' He was, indeed, '*dearer* than any of the others put together'.

From an early age, Arthur was destined for a military career. He played military games at the royal residence of Osborne, building earthworks and fortifications. At the age of 12 he was sent into an almost monastic life at Ranger's House, Green-wich, where he was tutored from 6.45 in the morning until 10 at night. At 15 he travelled around the Mediterranean, and the following year entered the army as a cadet at Woolwich and was commissioned into the Royal Engineers, before being transferred to the Rifle Brigade.

With his new regiment the Prince travelled to Canada – a visit which acquired the status of a royal tour. Upon his return, Gladstone wrote to Queen Victoria:

> Mr Gladstone had the honour on Wednesday of receiving a visit from Prince Arthur. He only echoes the general opinion in saying that the Prince's frank, intelligent, and engaging manners adorn the high station which he holds.

Prince Arthur's title – Duke of Connaught and Strathearn and Earl of Sussex – was created in 1874. When in 1878 (at about the time when this photograph of Arthur, in fancy dress, was taken) he declared his intention to marry Princess Louise, the daughter of Prince Frederick of Prussia, Queen Victoria was not amused. Writing in her journal, she declared, 'I could not help saying that I dislike the Prussians, and told him he should see others first, but he said it would make no difference.' But with uncharacteristic charity, she gave her consent, and they were married the next year.

He continued to serve in the Army; Queen Victoria remarked, 'I rejoice in having a son who has devoted his life to the Army, and who I am confident will ever prove worthy the name of a British soldier.' Given command of a bicycle regiment, he is reported to have fallen off and to have become intricately entangled with the mechanism of his machine while attempting to return a soldier's salute. His service in the war in Egypt in 1882 was more laudable, and was followed by a long period in India and as Governor-General of Canada.

Even into old age, Arthur was deeply involved in diplomatic and military affairs, in the Boy Scout movement and in Freemasonry, serving as Grand Master of England. He died in 1942 at the age of 91, the oldest surviving child of Queen Victoria, outlived only by Princess Beatrice who died two years later aged 87.

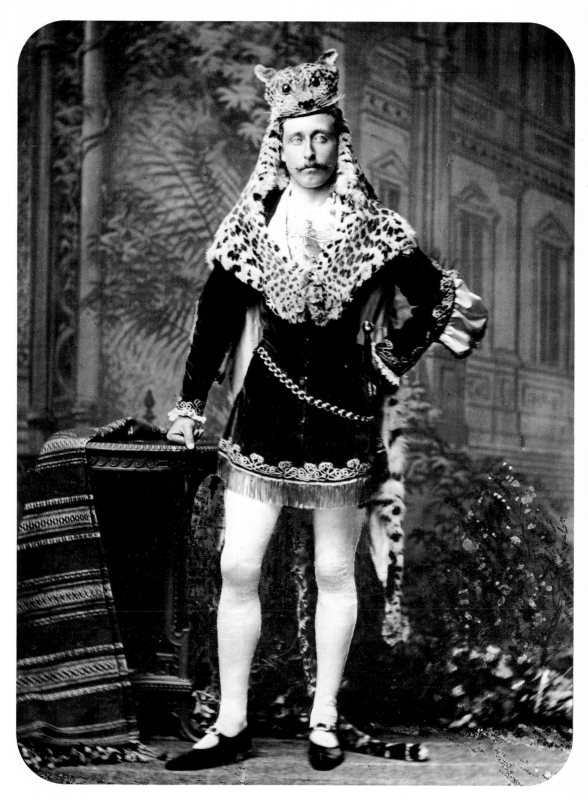

Edward, Prince of Wales
1841 - 1910

Elliott & Fry's portrait of the Prince of Wales, taken about 1882, shows him in his early forties. The picture, a good example of the formal style of photographic portraiture of the period, gives the Prince an air of solid confidence, emphasized by the conventional pose against 'baronial' studio furniture and the Classical overtones of the painted backcloth. From his middle years, the Prince was rarely pictured, except in formal state-occasion portraits, without a cigar either between his fingers or between his lips. In an age of outward propriety, particularly in portraiture, the detail lends a note of rakish modernity which unintentionally provides a touchstone for Edward's style.

To an institution as anciently traditional as the British royal family, he brought a gusto and a zest for good living in the style of his contemporaries which had been lacking for many years. In 1861 Queen Victoria disappeared from public view into a self-imposed seclusion as she mourned for her dead husband, Prince Albert. The lives of her son and heir and his warm and friendly wife, Alexandra, were in complete contrast to the Queen's. In 1863 the Queen had intimated that the London social life of the Prince and Princess of Wales should be restricted to the dinner tables of elderly and respectable statesmen and royal relatives. Seven years later the Queen had not changed her mind and wrote to the Princess Royal that the Prince and Princess of Wales

> lead far too frivolous a life and are far too intimate with people – with a small set of not the best and wisest people who consider being fast the right thing.

In 1874 the Queen's opinion still held firm:

> The Prince and Princess of Wales go far too much into Society, do not keep up the right tone, are not looked up to, living far too intimately with everyone irrespective of character and position.

The life-style of the Prince of Wales was certainly not all that a Victorian moralist could wish it to be and even now, for someone in his position, it would cause a great deal of unfavourable comment. Yet, Edward's indiscretions apart, he and his wife, by their hospitality and generosity, did a good deal to restore the prestige and regard for the monarchy which came to its full flowering during the last two decades of the 19th century.

Queen Victoria did her unintentional best to make it difficult for her son. Edward chafed for a position of state responsibility as well as a representative function under his mother's rule. She refused to allow him even a sight of state papers until he was well into his fifties. Gladstone, whom Queen Victoria disliked, took up the Prince's cause and made himself even more unpopular. The Prince's position was a galling one, since he was respected and considered throughout Europe, carried out a diplomatic function on his frequent visits abroad, yet was never fully aware of the details of the diplomatic scuffles through which he was obliged to pick his way.

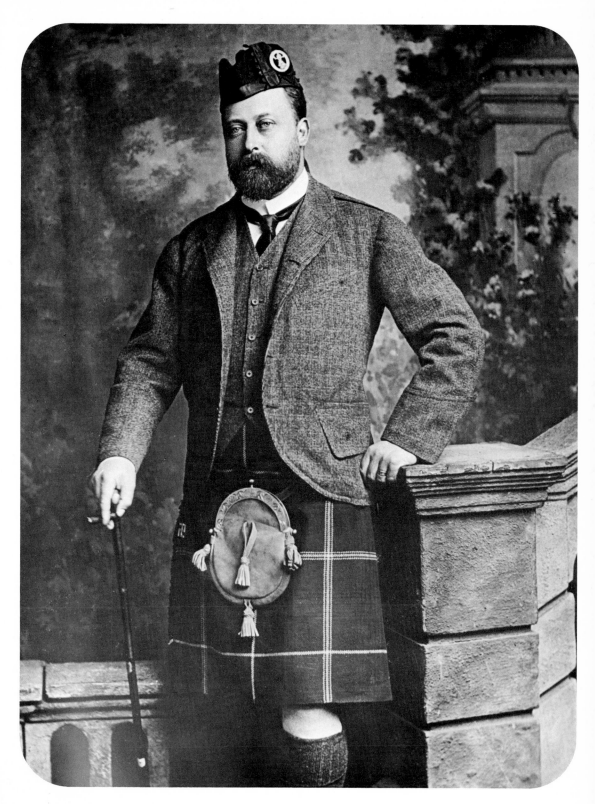

Alexandra, Princess of Wales
1844 - 1925

Princess Alexandra, the wife of Edward, Prince of Wales, was born in 1844. When this photograph was taken in 1883 she had had five children, of whom the eldest, Prince Albert Victor Christian Edward, the Duke of Clarence, was 19 years old. Her classic beauty remained throughout her life, a source of admiration to all who met her, particularly in her later years, when she was generally agreed to have the complexion of a woman half her age. She often looked more the sister of her children than their mother.

Alexandra was fond of her eldest son, known in the family as 'Eddy', but his education was a source of constant worry to her since she was continually disappointed by his poor form and evident apathy and inattention both at school and at HMS *Britannia*, the Royal Navy's training ship for cadet officers at Dartmouth, Devon. Her cares were increased by her sorrow at parting from any of her children. Although she had grown to live with such partings, since both Eddy and his younger brother Prince George had been to sea together as midshipmen, the autumn of 1883 saddened Alexandra as Eddy left her for Cambridge University and George to go to sea once more.

Yet Alexandra was more often the comforter than in need of comfort. Earlier in the year she had been a source of solace to her mother-in-law, Queen Victoria, when John Brown, Victoria's beloved Scottish manservant, had died. Since 1878, when one of Victoria's daughters, Princess Alice of Hesse, had died in Germany, Alexandra had grown closer to Victoria, who turned to her for advice and discussion of many family matters.

Her family dominated Alexandra's life: one of the most pleasant annual events was her summer holiday in Denmark, her native land. The European royal families were closely interlinked and large gatherings of royal relations assembled at Bernstorff, the Danish royal family's summer residence. On one occasion, in 1879, although there was political tension between Russia and Britain, Alexandra's husband, heir to the English throne, and her brother-in-law, the Czar of Russia's heir, spent a summer holiday under the same roof. It was a golden age of European Society, when aristocratic family bonds crossed political frontiers more smoothly than social bonds linked the people of one nation together.

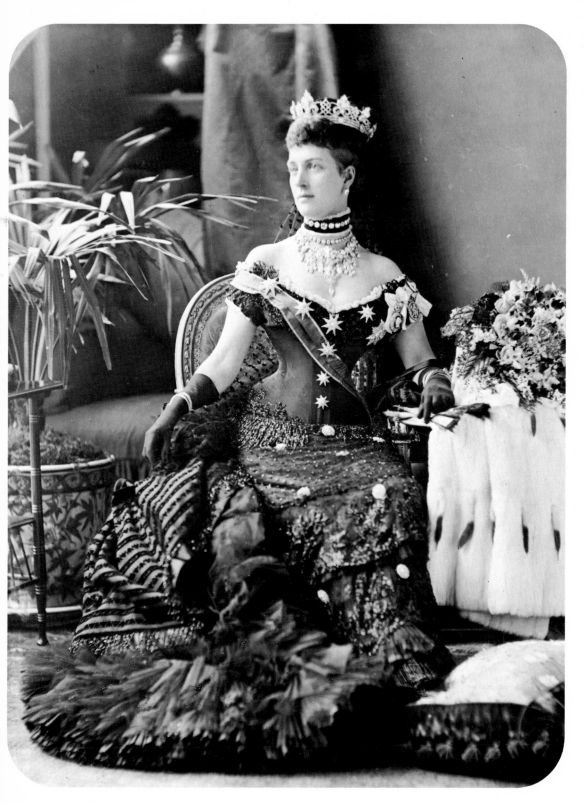

Children of the Prince and Princess of Wales

The nautical fashion in children's clothes was commonplace wear in a Victorian childhood. For the royal boys, at least, it was more appropriate than for many children throughout Britain who might have had to wear the garb without ever having been near the sea. William IV, the 'sailor-king', had been Queen Victoria's predecessor on the throne of England. More immediately, the royal children's parents, the Prince and Princess of Wales, took part enthusiastically in Cowes Week, the pinnacle of the annual yachting calender. Later in their teens the boys went together to the Royal Navy's cadet training establishment at Dartmouth in Devon. Prince George, the younger of the boys, subsequently pursued a career in the Navy.

Only George had an aptitude for the sea. The elder boy, 'Eddy', was sent to Dartmouth in the hope that it would encourage him out of a lethargy and lack of concentration which had marred his school-work and disappointed his parents from the beginning of his education. But Dartmouth did nothing educational for Eddy. Lord Ramsay, in his termly reports, virtually advised the Prince and Princess of Wales to remove their elder son from his charge. The Princess, in particular, was deeply troubled by Eddy's lack of progress, but both she and her husband knew their sons well enough (which was far from true in many Victorian families) to realize that the boys were very attached to each other and that to separate them in their middle teens would do more harm, to Eddy in particular, than good.

The characters of the two boys could hardly have been more different: George was intelligent and high-spirited, an outgoing, energetic boy whose enthusiasm for life was shared and fostered by his parents. Eddy, in complete contrast, was apathetic and apparently uninterested in whatever was proposed to him. More through inattention than stupidity he was slow to learn and his lack of application left him in his early years with little self-confidence. Although his good nature and gentle ways made up for his intellectual backwardness in the loving eyes of his mother and sisters, the Prince of Wales was not so taken. Eddy's sloth was a source of great irritation to his father, not least because Eddy was in direct line of succession to the English throne and the Prince of Wales, an energetic, perceptive and high-living man himself, found the prospect of eventually being succeeded by Eddy not to his liking.

At the time this photograph was taken, in 1875, the girls, who never figured as prominently in their parents' attention as did the boys, had not had time to grow into the rather diffident, unforthcoming young ladies who were a long time in finding suitable husbands (the middle daughter, Victoria, never did succeed). In their childhood, within the close family circle, they were uninhibited, cheerful girls. Their education was largely overlooked, apart from the rudiments and practice of music, and they were offered none of the opportunities open to the boys, nor were they ever allowed to seek those opportunities for themselves.

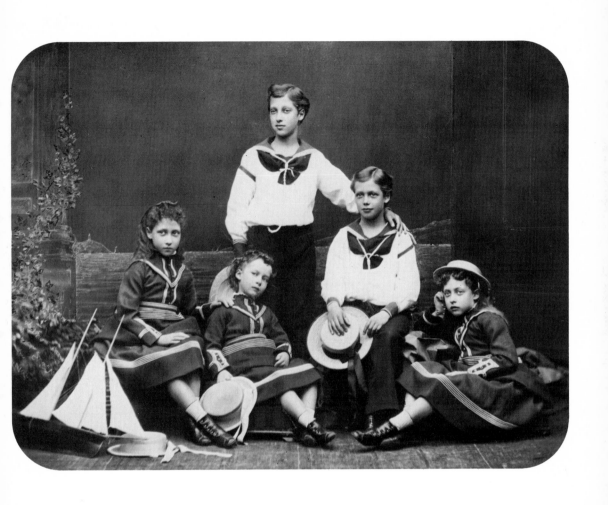

Prince Albert Victor
1864 - 1892

Shortly after the birth of her first child, Princess Alexandra, wife of Prince Edward, was outraged to learn from the six-year-old Princess Beatrice that Queen Victoria had decided that her grandchild should be called 'Albert Victor Christian Edward' (it could not be Albert alone, because, in her words, 'there can be only *one* ALBERT!') Thus, in strict obedience to the Queen, he was christened, but, almost as an act of defiance, he was never called by his parents anything but 'Eddy'.

Similarly, in contradiction to the rigid system of education Victoria and Albert had imposed on his father and uncles, Eddy was to receive only ineffectual tuition and scant discipline. As a child, with his brother George, he frequently received the admonition of the Queen, who described them as 'such ill-bred, ill-trained children'.

Most of the correspondence between Eddy and his family from this time has been destroyed, but its very loss and the survival of that between Alexandra and her second son, George, which is warm and emotional in tone, hints that she was gradually becoming aware that Eddy was not only retarded but dissipated, and, it seems likely, homosexual.

Having travelled round the world on HMS *Bacchante* and then entered the Army, Eddy was sent to India in 1889 at the time when a major scandal involving male prostitution broke in London. His only modern biographer, Michael Harrison, believes that Eddy was involved in this *cause célèbre* and that he was diplomatically removed from the scene while his participation in the affair was covered up. Harrison however, refutes the even more startling recent implication that Eddy and Jack the Ripper were one and the same (he identifies the Ripper as Eddy's tutor, J. K. Stephen).

Whatever the truth of the various rumours which circulated about the young prince, upon his return from India in 1890, when he was created Duke of Clarence, it was decided that the only suitable course of action was for him to marry and, it was hoped, settle down. Left to choose for himself, he picked Europe's possibly least eligible woman, the Princess Hélène d'Orléans, daughter of a pretender to the French throne and, what is more, a Roman Catholic (the British Constitution specifically prohibited the heir to the throne from marrying a Catholic). When this match was vetoed, a more suitable bride was found in Princess Mary of Teck. Eddy formally proposed to her at Luton Hoo in December 1891, and the wedding was arranged for 27th February 1892.

Illness was raging in the Royal Family. Eddy's brother, George, had caught typhoid the previous November, but recovered. Within two months Eddy had contracted influenza as an epidemic swept England; it turned to pneumonia and at Sandringham on 14th January 1892, to the dismay of his family and the nation, he died. Victoria, who had perhaps been closer to him than his parents, thought the loss 'more sad and tragical than any but one that had befallen her'.

Through this curious twist of fate, George became, on the accession of Edward VII, heir apparent and, himself marrying Princess Mary, was to rule as George V, ably reigning in the place of one who despite certain qualities of charm and affection was both intellectually and morally his inferior.

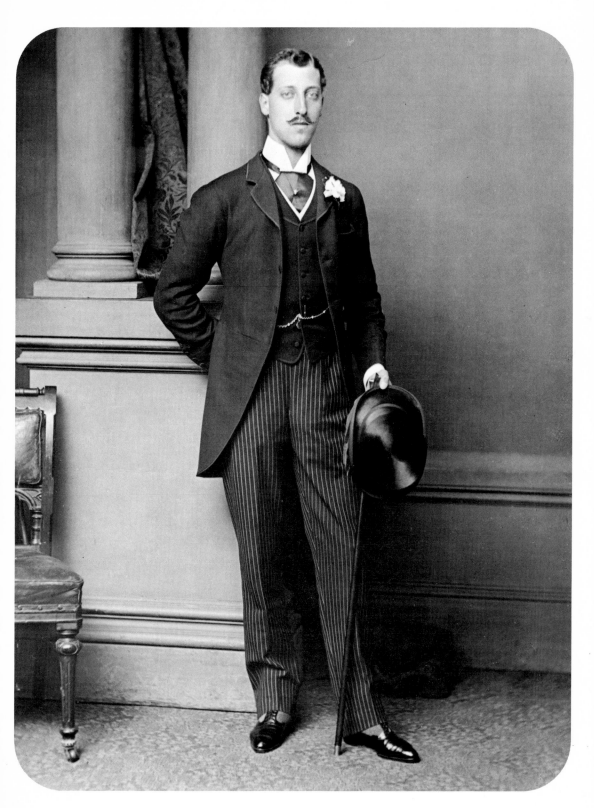

Princess Mary of Teck
1867 - 1953

Mary was not photogenic. 'She never ought to be photographed, as they do not do her justice,' a lady of the English court remarked. Her neat figure – corseted after the fashion of the day – and her alert, intelligent expression appear to advantage here, but her wild-rose complexion, her upright movements and the twinkle of amusement in her eye which was always rembered by her contemporaries, could not be reproduced. Her light brown hair, glinting golden in the sunlight, seems dark. She always wore a *bang*, an artificial fringe, a fashion of which Queen Victoria heartily disapproved: 'The forehead, is always a pretty thing to see,' she had written admonishingly to Crown Princess Frederick in 1885.

Practical, friendly and serious, Mary had made a favourable impression upon the ageing Queen Victoria, who thought her 'sensible', and the question of her future caused the Queen some thought. As the son of a morganatic marriage, the Prince of Teck, her father, had been considered fortunate to be permitted to marry a princess of Great Britain and Ireland, and to be granted the status of a duke in England. Indeed, he was doomed to pass his years in the continual redecoration of his family's houses at Kensington Palace and Richmond, for the Queen would allow him no position or responsibility within her court. As the inheritor of morganatic blood, Mary was ineligible to marry a German prince and was confronted with the unenviable prospect of also being too royal to marry a commoner.

In 1891, the question arose of a suitable match for the apathetic, troublesome Duke of Clarence, heir-apparent to the throne. Queen Victoria, undogmatic about morganatic marriages, approved of sensible, practical 'May'. 'Of course I accepted,' May recorded, unemotionally, in her diary. Edward and his family had been childhood friends of the princess and her brothers, but the match had been far from expected. The engagement was a short one. An epidemic of influenza swept Europe in the early 1890s and claimed more royal persons than the anarchist movement which was so notoriously active at the time; the young Prince Edward was one of its early victims.

His sudden death, as well as being a severe shock to his family, provoked months of gossip and speculation in the press and among members of the court as to May's future. A year later the announcement of her engagement to the Duke of York, Edward's younger brother, was greeted with much relief and little surprise. When, 17 years afterwards, her husband ascended to the throne as King George V, Mary became England's first British-born Queen Consort since the 16th century.

Charitable and sympathetic, Mary was much loved as a queen. Keir Hardie, founder of the Independent Labour Party, once said, 'When that woman laughs, she does laugh, and not make a contortion like so many royalties'.

The Family of Mary of Teck

A great-granddaughter of George III, but a princess without land or fortune, Victoria Mary Augusta Louise Olga Pauline Claudine Agnes of Teck ('May' to her family and friends) could trace her lineage to the House of Hapsburg, to St Stephen of Hungary and to the Kings of Poland on her father's side, and to William the Conqueror on her mother's. She was named, respectfully and with a hopeful eye to the future, in honour of some of the more illustrious ancestors of both.

Elder sister to three brothers, May was a Victorian tomboy. As a young girl she was sensitive and intellectual, a listener and an observer, the family peacemaker. She was close to but quite overshadowed by the extrovert personality of her extraordinary mother, Mary of Cambridge, with whom she is pictured here.

May's mother, a jovial, enthusiastic and imperious princess, was popularly known as 'Fat May'. Her inherited size had undoubtedly been the cause of much delay in her search for a suitable match. Queen Victoria, at pains for almost a decade to disembarrass her cousin by means of her influence among the Central European principalities, was almost disposed to concede to Lord Clarendon, her irreverent Foreign Secretary that 'no German Prince will venture so vast an undertaking' when, at the age of 30 and after an abbreviated courtship, she at last contracted a marriage to the handsome but impecunious Prince of Teck, of the royal house of Württemberg.

Once married, the Duchess of Teck entered with gusto and with an opulence amounting to a little over double her yearly income, into a new role as hostess in London Society. She entertained extravagantly from both of her large houses with the help of the long-suffering Cambridge family, the goodwill of tradesmen patient, apparently, to the point of martyrdom, and the bounty of Baron and Baroness Coutts, bankers and friends of the family.

In a convivial atmosphere, amid an expanding mountain of debt, young May and her brothers, Prince Adolphus, 'Dolly', always closest to her, happy-go-lucky Prince Francis and 'Alge', Prince Alexander George, the favourite of their mother, passed their childhood. In 1883, the year before this photograph was taken, the family was advised, with tact and the persuasive influence of the Queen's approval, to leave for Europe forthwith, there to 'economize' until such time as they were able to return once again to London.

Refusing to be shamed, the irrepressible Duchess established herself, her husband and her brood in Florence in a style not far removed from that she had maintained in London. Here, her serious-minded daughter took advantage of her two years of exile to improve her mind with lessons in drawing, painting and language, and to acquire that self-assurance and polish which a few years hence moved Queen Victoria to write of her as 'so charming and *distinguée*'.

Cardinal Manning
1808-1892

An Anglican archdeacon at the age of forty, and a Roman Catholic Cardinal by the time he was 57, Henry Edward Manning was perhaps the most important of the 19th-century converts to the Roman Catholic Church.

A man of ascetic appearance, with clear and penetrating grey eyes and distinguished bearing, he was an enigmatic character. 'There was an air of subtlety about him,' wrote Bramwell Booth, son of the founder of the Salvation Army, 'which made one never quite sure of one's grip.' He has been portrayed as a cold and ruthless schemer, a dry and unemotional personality whose most unattractive trait was his intense ambition. Yet his sympathy for and popularity among the poor was boundless, and among those aspects of his nature most praised by his friends were his exquisite manners, his immeasurable tact and his genius for persuasion. He was a brilliant host. 'Now you're just wrong about my darling Cardinal,' wrote Ruskin to his sister. 'He gave me lovely soup, roast beef, hare and currant jelly . . . and those lovely preserved cherries like kisses kept in amber. And he told me delicious stories all through lunch. *There!*'

An eloquent preacher, a sympathetic confidant and a good sportsman, he was popular and active in the Anglican Church, ably upholding the traditions of the English rural parson. 'He were a wonderful Churchman,' reported one of his parishioners, 'he looked like an archangel when he prayed.' He discreetly supported the Oxford Movement, to which he was introduced through the *Tracts for the Times* in 1833. These pamphlets, produced by the Oxford high churchmen Edward Pusey, John Keble and John Henry Newman, heralded a Catholic revival in England. Produced after the 1832 Reform Act, they sought to warn the Anglican community of the danger that power over the Church might fall into the hands of an unsympathetic secular authority. Encouraged by Newman, Manning was intellectually attracted towards the Oxford Movement, but remained a loyal Anglo-Catholic for more than a decade. On publication of Newman's *Tract No. 90*, which attempted to reconcile the Roman catechism with the 39 Articles, he broke with Tractarianism. When, in 1850, the Privy Council, a secular body, overruled an ecclesiastical decision, he repudiated the Anglican Church and became a Roman Catholic.

To an England whose orthodox Church was described as the Sunday edition of the Tory Party, Manning brought a new national respect for his adopted faith. He fought a crusade against the social ills of industrial society, battling with militant enthusiasm against the status quo of the poor, against the scourge of child employment and adult unemployment. His intervention on behalf of the dock strikers of 1889 not only won them a 'tanner an hour', it symbolized the advent of a new social and above all practical Christianity.

Yet in his fourteen-year progression from convert to Cardinal and to the supreme honour of a refusal of the papal throne, the tactics he employed to achieve his ends were highly suspect. 'Under his seraphic beatitude,' the British Ambassador to Rome informed his Government, 'he retains a wheedling and energetic policy.' He was scathing and intolerant towards those who opposed him, and jealous of his rivals, Newman in particular. His relationship with George Talbot, a busybody and an intriguer who had the ear of the pope, caused great suspicion. 'A decidedly clever fellow,' Florence Nightingale described the eminent Cardinal.

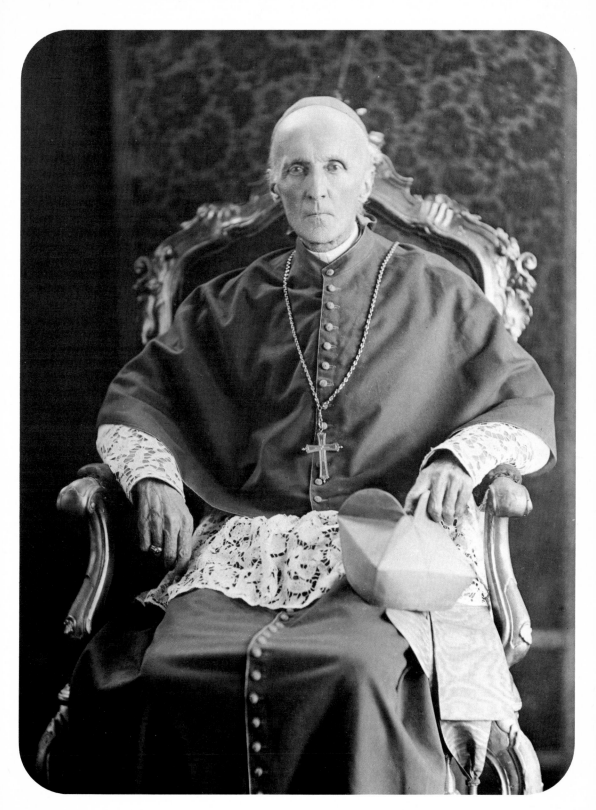

Lord Shaftesbury
1801 - 1885

In his eighties, Anthony Ashley Cooper, 7th Earl of Shaftesbury, looked back with profound gloom upon his life, which had been dedicated to the reform of the least commendable aspects of his age.

He was its greatest philanthropist. Although he was an aristocrat, an ultra-Tory and an imperialist, he was also a pious and active Evangelist with an unshakeable belief that man's spiritual nature could be as well expressed collectively in national and even international politics, as in individual charitable actions. He began his political career with a compassionate struggle for the reform of the treatment of lunatics, and as leader of the Factory Reform Movement of 1832, fiercely piloted a series of Factory Acts through an admiring, if somewhat unwilling and highly discomfited, Parliament. His dedication to the improvement of public health conditions in the nation's sprawling, expanding, insanitary industrial cities made him the 19th-century expert on destitution. 'I feel,' he once declared, 'that my business lies in the gutter, and I have not the least intention to get out of it.'

The gloom and pessimism to which he succumbed as he grew older was partly the result of a natural tendency towards melancholy and self-pity, and partly the result of his preoccupation with religion which amounted at times to an unhealthy obsession. He had suffered a desperately miserable childhood. His parents, strict to the point of cruelty, neglected him. With his older sisters and younger brothers, he was brought up by servants and schoolteachers, and his first school instilled in him a horror of oppression and cruelty. Religion was his childhood's consolation, imparted to him in the form of Bible stories, prayer and homely love from a servant, Maria Mills. He saw his task in life to be the removal of the sin and squalor of his age; his career at an end, he felt he had failed, and the pessimistic analyses of society with which he filled his diary culminated in prophesies of worse to come.

Cranky, cantankerous and temperamental, he was yet a charming, enthusiastic and eminently domestic man. He loved children, and fathered ten of his own. With his adored wife Min, he travelled a good deal, after the manner of the 19th-century aristocracy, about the great houses of England and Scotland, and upon grand tours abroad, commenting aptly and humorously upon all he saw, for he was an inveterate sightseer. He was never rich. After five salaried months at the start of his career, he accepted no paid office, and after succeeding to the earldom, was forced to shoulder the considerable debts of his estate.

He turned a polished front to the outside world, and discreetly concealed his shortcomings. Considered by all to be a simple, genial and generous man, the world was startled to see the self-righteousness, vanity and suspiciousness of his nature revealed in published extracts from his diaries. After reading Shaftesbury's official biography, Gladstone declared that he 'could not have believed from the constantly kind relations between us that I could have presented to one sustaining those relations a picture of such unredeemed and universal blackness . . . I am now inclined to regret what I had used to reflect upon with pleasure, that I had broken bread at Lord Shaftesbury's table, for he must have been a reluctant host.'

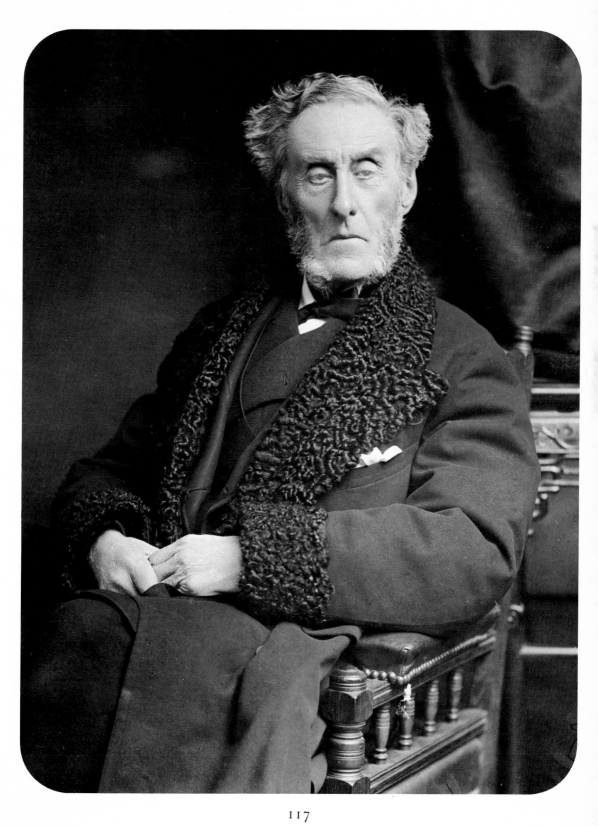

John Morley
1838 - 1923

John Morley was a man of versatile talents, a hot temper and unconventional behaviour. He was an irreverent journalist, a Liberal atheist statesman who dared in the mid-Victorian age to spell 'God' with a small *g* and lived for years with someone else's wife.

From Oxford he was called to the Bar, but instead settled in London, and tried to earn a living as a writer. He gradually acquired a reputation as a journalist and an individualistic thinker. His growing fame won him the editorship of the *Fortnightly Review* which, between 1867 and 1882, he turned into the nation's leading organ of radical opinion. At the same time he made his name as a biographer, with a life of Edmund Burke, and as a philosopher, with his treatise *On Compromise*.

An unashamed intriguer and well-connected in the political world, two failures to win a seat in Parliament did not deter Morley from pursuing his political ambitions. He was a close friend of Joseph Chamberlain, President of the Board of Trade and a member of the Cabinet, who was also the unofficial leader of Parliament's extreme radicals. Chamberlain's political ally was Charles Wentworth Dilke, a doctrinaire Radical and once a committed Republican. Both saw in Morley a spokesman through whom they could state in the Commons views which they shared in private. In 1883 Dilke's brother, Liberal member for Newcastle-upon-Tyne, resigned because of illness and Morley, by now editor of the *Pall Mall Gazette*, stepped into his shoes.

Though too rhetorical a speaker for his speeches always to achieve their desired effect, Morley extended his influence in Parliament. He consorted less with Chamberlain and allied himself more closely with Gladstone, eventually becoming one of his most ardent supporters. Queen Victoria mistrusted him. She thought him a Free Thinker, 'in fact a Jacobin'. With his colleagues he was so outspoken, intransigent and temperamental that he was tartly nicknamed Honest John.

The peak of his political career came in 1905, on the Liberals' return to office, when he became Secretary of State for India. Despotic, and privately believing India to be unfit for self-government, he nevertheless worked towards more representative government there. In 1908 he entered the House of Lords as the First Viscount Morley. One of his last political acts was to startle that august assembly with a reasoned speech in which he threatened the lords with a mass creation of Liberal peers should they fail to pass the controversial Parliament Bill. He won his majority.

In many ways, Morley was typical of the age in which he lived. 'Only a Victorian,' wrote Lytton Strachey, 'having made his reputation by writing the lives of Diderot, Rousseau and Voltaire, would, on his return from Paris, have thrown, in horror, two French novels out of the railway-carriage window.' In his *Recollections* he passed over Gladstone in a few passages, while 'devoting a whole long chapter to a series of extracts from the most esteemed authors on the subject of Death'. Such details, thought Strachey, depicted both Morley the Man and Morley the arch-Victorian. 'The Victorian Age, great in so many directions, was not great in criticism, in humour, in the realistic apprehension of life. It was an age of self-complacency and self-contradiction. Even its atheists were religious.'

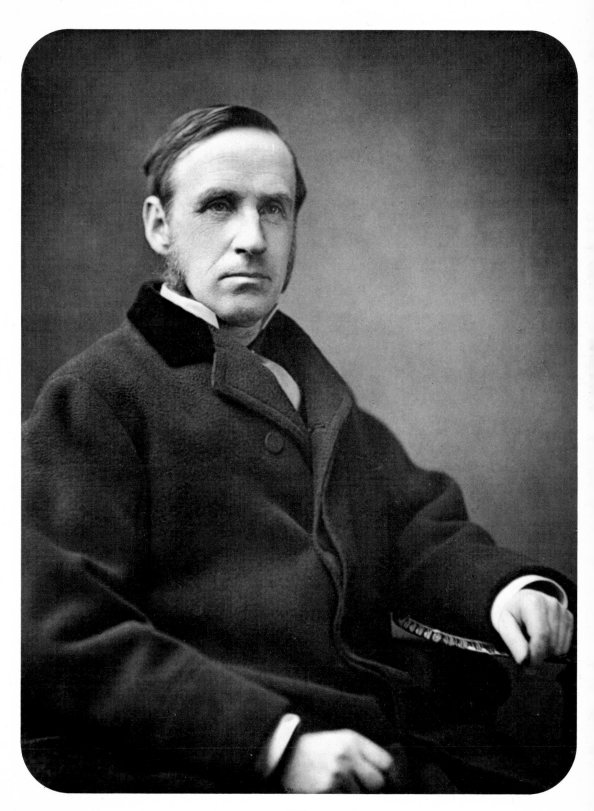

Joseph Chamberlain
1836 - 1914

Chamberlain entered politics from a commercial background (he managed his father's Birmingham screw factory), becoming successively a town councillor and mayor of Birmingham, and Member of Parliament for that city in 1876. Attracting immediate attention as an able radical politician, in 1880 Gladstone appointed him President of the Board of Trade. His resignation from the office of President of the Local Government Board in 1886 over Gladstone's Irish Home Rule Bill split the Liberal Party, and he later became leader of the breakaway Liberal Unionists. Allying frequently with the Conservatives, Chamberlain was appointed Colonial Secretary in Lord Salisbury's Conservative Government of 1895. In this office, he acquired a reputation as a great colonial administrator and laid the economic foundations of the British Commonwealth. He was an able politician, noted for his wit and oratorial skill, and was the father of two leading 20th-century politicians, Austen Chamberlain and Neville Chamberlain.

His famous mask-like visage in reality masked nothing at all; as one of his biographers has remarked, 'the apparent Chamberlain was the real Chamberlain'. A decisive, practical and objective politician, in his professional as in his personal life there was no introspection, no time for personal or domestic details or even, it would seem, for any 'private' life. His two wives were both dedicated to his political ambition, and his relationship with potentially the third Mrs Chamberlain (Beatrice Potter, later the wife and working companion of the socialist statesman, Sidney Webb) was terminated largely through his intransigent stand in their political discussions.

At the time this photograph was taken, Chamberlain was beginning to make his mark in British political life. In 1877, Gladstone wrote prophetically,

> He is a man worth watching and studying: of strong self-consciousness under most pleasing manners and I should think of great tenacity of purpose: expecting to play an historical part, and probably destined to it.

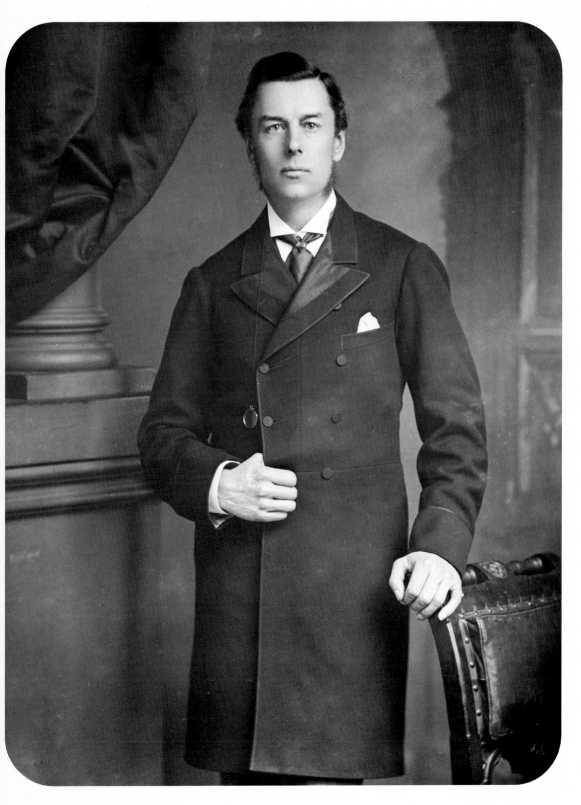

Lord Randolph Churchill
1849 - 1895

Lord Randolph Churchill, the younger son of the 7th Duke of Marlborough and father of Sir Winston Churchill, is seen here in a photograph taken in the early 1880s. Lord Randolph was in his mid thirties. He was a Member of Parliament and had made a glittering marriage to Jennie, daughter of Leonard Jerome of New York. For two years following their marriage in 1874, Lord and Lady Randolph had lived the life of elegant and vigorous gaiety which was open to the rich and privileged group of people who formed London Society.

Society was led by the Prince of Wales and his opinion as to who was or who was not acceptable became unwritten social law. In 1876, the Prince was touring India. In his retinue travelled Lord Aylesford. At home, the Marquess of Bland-ford, Lord Randolph's elder brother, was creeping in, at dead of night, through the side door of Lady Aylesford's house. Their love was passionate; to their families they declared their intention of divorcing their respective partners and marrying each other. But the very word 'divorce' was anathema to Society. Lord Randolph telegraphed the Prince of Wales, in India, to persuade Lord Aylesford to refuse his wife's request for a divorce. Lady Aylesford produced compromising letters written to her in former years by the Prince of Wales, and gave them to Lord Randolph. He threatened Princess Alexandra, the Prince of Wales' wife, that he would make the letters public unless the Prince prevailed upon Aylesford.

Understandably the Prince was furious at Lord Randolph's attempt to black-mail him and he pronounced a social ban on the young Churchill couple. His decree was virtually absolute and for almost seven years the Churchills had to seek their pleasures beyond the dining tables of London Society.

The ostracism was so sweeping that the Duke and Duchess of Marlborough, Lord Randolph's parents felt themselves obliged to withdraw, in some dignified way, from the embarrassment caused by their son's conduct. To enable them to do so Disraeli, the Prime Minister, offered the Duke of Marlborough the post of Viceroy of Ireland. In 1877 the family decamped from Blenheim Palace to the Castle at Dublin. Although embittered by the revenge that the mandarins of the drawing-rooms had wreaked upon him and his wife, for upholding his elder brother, for whom he did not much care anyway, Lord Randolph used his time to advantage.

In 1880, he and his wife returned to London. During his time in Ireland he had made an intensive study of Irish social conditions. Gladstone's Liberal Government was faced with the difficult and dangerous problems of Home Rule for Ireland. Lord Randolph's knowledge gave sound substance to his developing rhetorical skills as a Parliamentarian. From his return to London, he was very much 'the coming man'.

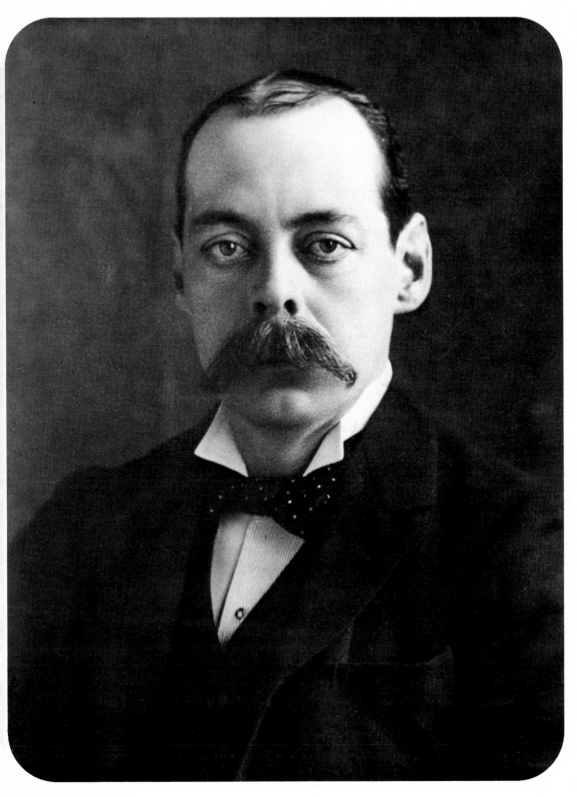

Lady Randolph Churchill
1854 - 1921

Lady Randolph Churchill, mother of Sir Winston Churchill, was born in Brooklyn, New York. At various times her father, Leonard Jerome, owned most of the Pacific Mail Line of steamers, co-edited the *New York Times* and founded Jerome Park and the Coney Island Jockey Club, two historic American racecourses. One of her earliest memories was of the Jerome house in Madison Square draped in huge swathes of black and white material, in mourning for President Lincoln.

Her character firmly rooted in the expansive confidence of rich New York society, Jennie Jerome lived with her family in Paris from 1867 onwards. Her initiation into European society in the surroundings of the final flowering of the French Empire gave her the insights and the tastes which charmed her peers in England when she married Lord Randolph Churchill in 1874.

In her memoirs Lady Randolph mentions only briefly the 'Aylesford incident' which was the cause of the temporary removal to Dublin of the Duke of Marlborough and his son, Lord Randolph Churchill, with their respective families.

Lord and Lady Randolph took up their lodgings in the Private Secretary's lodge in Phoenix Park, Dublin. Whilst Lord Randolph occupied himself increasingly with the affairs of the House of Commons, in which he sat as Conservative member for Woodstock, Oxfordshire, Lady Randolph exchanged the 'frivolous society' of London for the entertainments of aristocratic Ireland.

One her favourite pastimes was hunting. In the photograph opposite she is seen dressed for the hunt. She travelled widely over Ireland, as her father-in-law, the Viceroy, took a number of country houses during his period of office. By the time the family left Ireland, Lady Randolph believed that she had hunted throughout the country with all but two of the packs of hounds then established in Ireland.

In spite of her privileged position, Lady Randolph was not blind to the grim conditions in which many of the people of Ireland were forced to live. She pitied the peasantry in their mud-hovels, but saw no solution to their degrading problems. But her helpless sympathy did enable her to understand the passionate interest which her husband began to take in the affairs of Ireland which occupied a vital place in English politics. During the period of the Duke of Marlborough's Viceroyalty, Lady Randolph sustained and encouraged her husband's political ambition and refused to pine for the dash and variety of London Society which was largely closed to them.

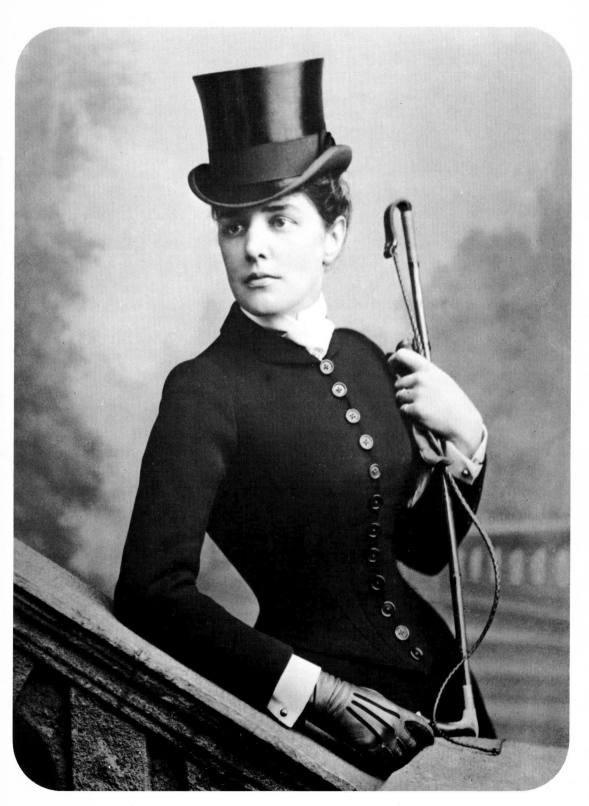

Arthur James Balfour
1848 -1930

Arthur James, first Earl of Balfour, was one of the last of a long tradition of British aristocratic statesmen. Immensely wealthy and socially supremely well-placed (he was a member of an ancient Scottish family, nephew of Lord Salisbury, who became Prime Minister in 1885, and godson of the Duke of Wellington), he occupied a commanding position in British Society and politics for over half a century. In his youth, he became the acknowledged leader and arbiter of a group of intellectual and cultured men and women known as the 'Souls', as a result of which he acquired something of a reputation as an aesthete and dilettante. In addition to his advantage of birth, which won him such sobriquets as 'Prince Arthur', he had undoubted gifts as an orator, administrator and scholar. He was the author of several important philosophical treatises, including *Defence of Philosophic Doubt* and *Theism and Humanism*, and was noted for his aphorisms – 'History never repeats itself; historians repeat each other', 'Everything is now permissible, even orthodoxy' – and for his often sarcastic wit; when shown the newly built skyscrapers of New York in the 1920s, a proud official who explained to Balfour that they were totally fireproof was rebuffed with the sole comment, 'What a pity!'

As Chief Secretary for Ireland, Balfour ably settled a number of internal problems and succeeded in bringing about a temporary peace to the troubled country, although to those who opposed his appointment he became known as 'Bloody Balfour'. In 1902, as leader of the Conservative Party, he became Prime Minister. Ousted four years later, he resigned from the party leadership in 1911, but later served as First Lord of the Admiralty and Foreign Secretary. In the latter role, he is chiefly remembered as the architect of the so-called Balfour Declaration, which promised a national home in Palestine for the Jews.

His biographer, Kenneth Young, describes him thus:

> . . . he was an agreeable man, tall and handsome, though sometimes languid, with notable eyes – not large, but often shining with humorous or sympathetic interest, less frequently half-abstracted as though regarding some absorbing inner landscape.

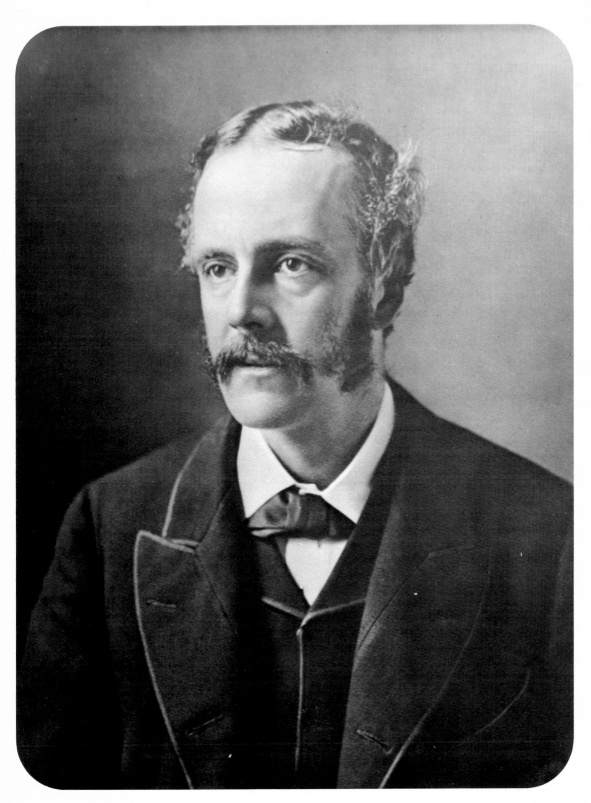

William Ewart Gladstone
1809 - 1898

The dominant figure in British politics in the 19th century, Gladstone became a Member of Parliament at the age of 23. His oratory soon made him stand out as 'the rising hope' of his party. He became successively President of the Board of Trade and Chancellor of the Exchequer, Leader of the Liberal Party in 1866 and Prime Minister two years later, and for three further terms up to 1894. A man of immense energy (his one-time secretary, Lord Kilbracken, declared that if the energy of an ordinary man equals 100, and that of an extraordinary man 200, Gladstone's would be 1,000), his writings alone would have made him remembered as a leading Victorian. Apart from such works of scholarship as his translations of Horace's *Odes*, he left about 250,000 documents (now largely in the British Museum) including personal records and letters to 12,000 correspondents – the most important single collection of papers of the entire 19th century.

The son of a wealthy Liverpool merchant, he was educated at Eton and Oxford. He renounced his intention to enter the Church in deference to his father, who urged him to become a politician, but retained a lifelong religious conviction which was the mainspring of his personal life and the guiding light of his political aspirations. It also explains the curious behaviour which often almost cost him his reputation and laid him open to blackmail. One of the founders of the *Church Penitentiary Association for the Reclamation of Fallen Women*, and other similar organizations, he would patrol the streets of London at night, seeking out prostitutes whom he attempted to rehabilitate, with the aid of his wife who shared his Christian motives.

Mrs Gladstone told John Morley that her husband's biographer (who Morley was to become) would have to learn to understand his high-minded idealism and particularly to realize that there were two Mr Gladstones – one impetuous and uncontrollable, the other immensely self-controlled and with an intense strength of purpose. Gladstone was a man whose moral power made him stand out against his political enemies. Even when he lost a particular battle, he invariably emerged as morally the victor over the narrow-minded opponents of his far-reaching liberalism. His mastery of the English language, his melodious voice and the dramatic skill with which he delivered his addresses, made him the outstanding orator in British politics for half a century, while his numerous political achievements mark him out as a giant of the period. Queen Victoria never managed to come to terms with him, but her son and grandson, both future kings of England – Edward VII and George V – held him in such high regard that without consulting her they elected to assist in bearing his coffin to Westminster Abbey.

His secretary, Sir Algernon West, wrote of his first meeting with Gladstone in 1868, slightly earlier than the date of this photograph:

> He was sitting, as I see him now, at his writing table, wearing a dark frock-coat, with a flower in his button-hole; a pair of brown trousers with a dark stripe down them, after the fashion of twenty years earlier; a somewhat disordered neckcloth and a large collar, the never-ending subject of so much merriment in contemporaneous caricature; and I noticed the black finger-stall which he invariably adjusted over the amputated finger on his left hand before he began to write.

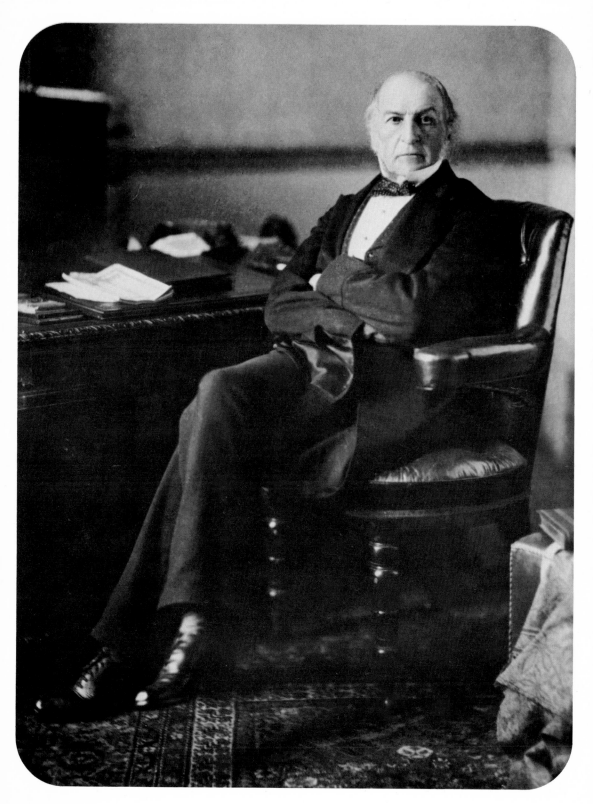

David Lloyd George
1863 – 1945

Like Gladstone, Lloyd George pursued a career in British politics first as a Member of Parliament, then as President of the Board of Trade and Chancellor of the Exchequer. He became Prime Minister in 1916. In an unpublished memoir, a contemporary, D. R. Daniels, described the youthful Lloyd George, depicted in this photograph:

> I remember his attractive smile and the incomparable brilliance of his lively blue eyes as though it were yesterday . . . I remember going home and saying to my wife . . . that I saw in G. something I had not found in any of the young Welshmen who were my friends then, on the crest of the wave of political and social promise. He seemed nimbler in mind and bearing, more daring in his views, more heroic in his looks (though he smiled most of the time) than any.

The ambition of the young Welsh solicitor led in 1890 to his election as Member of Parliament for Caernarvon, a seat he held for nearly 55 years. He was not, however, fully to make his mark as the 'Welsh Wizard' until the 20th century, when he introduced many of the most important social reforms in England's history. Until then, the aspiring Lloyd George we see here could win only the following slanted praise from a contemporary:

> In the features can be read an inflexibility of purpose compatible with infinite pliability of method; an impatience of opposition; even a certain ruthlessness – one of the abler Roman Emperors of the later period, from Illyria or Spain, might have had such a face. It is not the face of a great master of statecraft; the brain behind those rather sceptical and mocking eyes is quick and vigorous, but neither capricious nor subtle; it enjoys an intellectual game of draughts, but chess is rather beyond it.

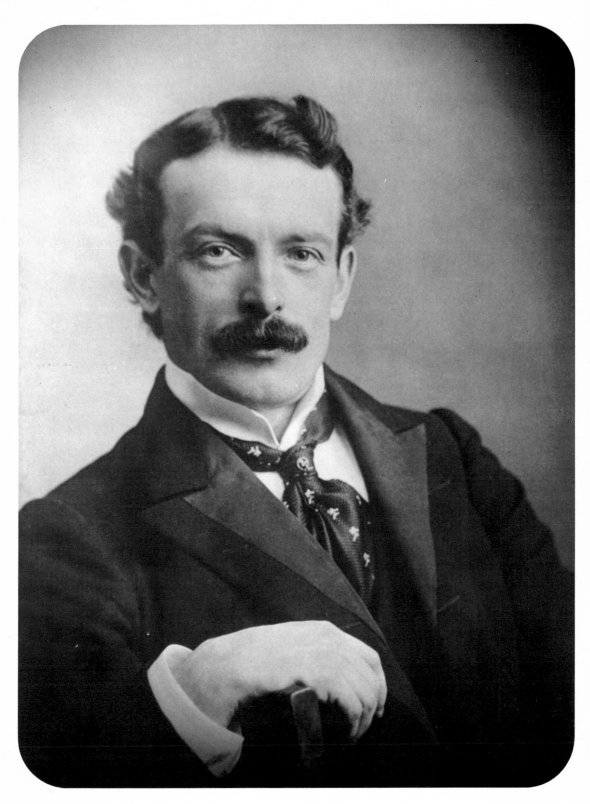

Paul Kruger
1825 - 1904

At the age of 11, Paul (or, in full, Stephanus Johannes Paulus) Kruger joined the Great Trek from British rule in South Africa's Cape Province to found the Orange Free State, Natal and Transvaal. Brought up as a shepherd with uncouth ways and virtually no formal education, he followed a life of strict Dutch Calvinist orthodoxy, reading nothing except the Bible, abstaining from all liquor and ruling as a patriarch over a household which contained the sixteen children who were to make him a grandfather to 120. Yet despite, and to some extent through, the rigorous and simple life he was compelled to lead, he showed himself to be a dynamic and resourceful leader and able diplomat. When the British annexed the Transvaal in 1877, he became his people's champion in their struggle for independence, visiting London to plead his case before Disraeli. Failing to achieve his aims, he returned to organize passive resistance to the British, attempting in 1880 to negotiate with Gladstone. At the outbreak of war in 1881, Kruger was appointed head of the provisional government, and in 1883 was elected President of Transvaal, an office he held until 1900.

After 1886, when the British joined the gold rush which drew thousands into the Witwatersrand area, Kruger felt his people, whom he described as 'God's People', threatened by the influx. In attempting, through strict residential requirements, to restrict the franchise to long-established settlers, Kruger incurred the displeasure of the British Government and after years of squabbling, precipitated the Boer War of 1899 to 1902. After British military successes in 1900, he visited Europe in an attempt to formulate anti-British alliances. Now an old man, his powers waning, he failed in his endeavours and settled in Utrecht where he dictated his *Memoirs*. He died in Clarens, Switzerland, his body resting temporarily at the Hague and later being buried in Pretoria.

This photograph depicts 'Oom (uncle) Paul' during his diplomatic visit to London in 1877. The explorer Henry Morton Stanley met him some years later and described him as, 'A Boer Machiavelli, astute and bigoted, obstinate as a mule, remarkably opinionated, vain, puffed up with the power conferred upon him, vindictive, covetous, and always a Boer, which means a narrow-minded and obtuse provincial of the illiterate type.' One of his modern biographers paints a similarly unattractive picture of his physical appearance:

> In old age . . . his eyes became weak, and his eyelids were swollen, the left eyelid drooping so as to give the eye a half-shut appearance. Underneath the eyes there were deep furrows, and when he was old the skin about his eyes was darkly discoloured. His mouth was fairly wide, but not unduly large. His lips were always tightly compressed. His nose was prominent, and broad at the nostrils. His ears were large though in old age they were close to his head. At all times he had a serious expression, but after the War of Independence his face gave an impression of settled melancholy, though it would not be fair to describe it as morose, as some writers have done.

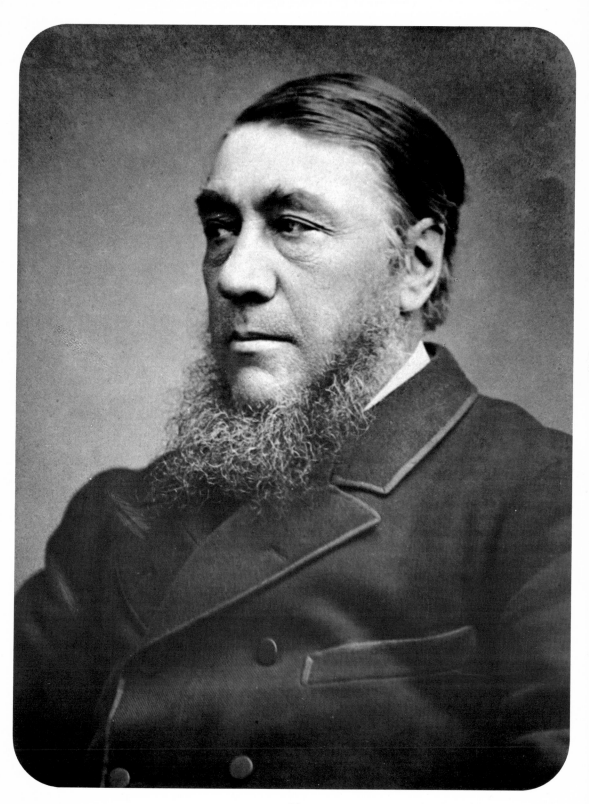

Sir Donald Currie
1825 - 1909

Scots-born Donald Currie, the founder of the Castle Steamship Company, learned the shipping trade in the Liverpool offices of Cunard where he became head of the cargo department. He set up the 'Castle' shipping company in 1862, sailing between Liverpool and Calcutta. After 1865 he used London as his English port, and in 1872 began sailings between London and Cape Town. When, in 1876, the Cape Parliament divided the mail shipping contract between the the Union Steamship Company and Castle, they amalgamated as the Union-Castle Mail Steamship Co.

Currie became a noted authority on shipping and on South African affairs, and in 1875 was, at the request of Lord Carnarvon, given the job of negotiating between the Presidents of the Orange Free State and Transvaal Republic regarding the occupation of the Kimberley diamond fields. He was also involved in President Kruger's negotiations with the British Government in 1877. Through his ships and private telegraph lines, Currie was the first person in England to hear of the Zulu massacre at Isandhlwana, and was able to organize the dispatch of reinforcements on his ships within 48 hours. Later, his ships were used to send troops to South Africa during the Boer War. Currie was a Liberal Member of Parliament and intimate friend of Gladstone, a wealthy landowner, a collector of works of art – especially paintings by Turner – and a philanthropist who gave large sums of money to University College Hospital, London, to Edinburgh University and other educational and charitable institutions.

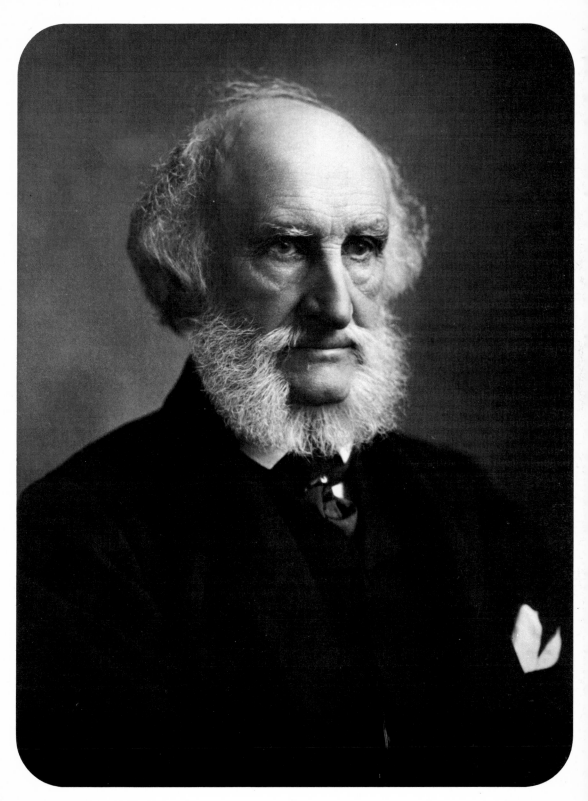

Baron von Reuter
1816 - 1899

A German Jew who was converted to Christianity, John Julius Reuter was one of the first to exploit the commercial potential of the electric telegraph.

Supreme inventiveness was his greatest asset. In 1849, a political émigré from Berlin's year of revolution, he set up his first news service in the dingy living room of a rented Paris flat. For a few months he and his young wife lived by translating items from the French journals which they sold to provincial German papers. When the Prussian State Telegraph line opened on 1st October 1849, Reuter set up his own office at the Aachen end, supplying bankers and merchants with financial information which he brought from Antwerp and Brussels via the mail trains. In the spring of 1850, a line was opened between Paris and Brussels, and he connected the French and German systems by using 40 carrier pigeons carrying despatches in muslin bags under their wings. When the lines were extended, leaving a five-mile-gap between Quievrain and Valenciennes, he covered it with relays of horses. He moved across the Channel when the expanding telegraph system finally overtook him.

Just one month before the first telegraph line was opened between Dover and Calais, Reuter opened England's first telegraphic news office on 14th October 1851, at No. 1, Royal Exchange Buildings in the City of London. The Stock Exchange was his first client; *The Times* thought the new cable a 'great bore' and for seven years, while Reuter extended his services as far afield as Athens and the Black Sea, the British Press failed to see how his agency could help them. Eventually, in 1848, the *Morning Advertiser* accepted a two-week trial. Within six weeks even *The Times* capitulated. The following year Reuter achieved his first notable success by securing an advance copy of Napoleon's speech of 7th February, before the French legislative chamber.

Ten years later Reuter's resourcefulness lay behind the scoop of the decade. In order to intercept the mail boats from New York to Southampton, he set up his own telegraph line from Cork to Crookshaven on the extreme southwestern tip of Ireland. Despatches packed in long wooden canisters were collected by agents in small boats using nets at the end of long wooden poles, and raced to the land telegraph lines. Using this system, Reuter was able to tell the world two days ahead of his closest rival of the death of Abraham Lincoln on 14th April 1865.

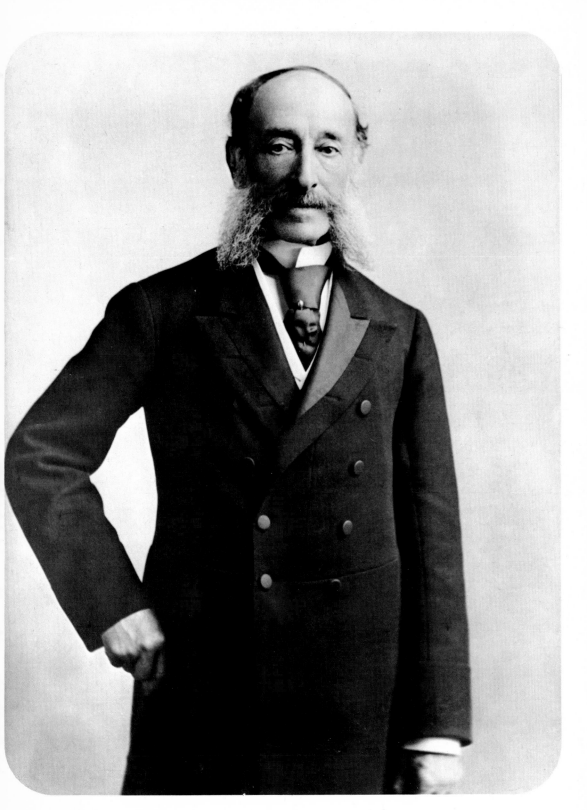

Horatio Herbert Kitchener
1850 – 1916

Kitchener, at the time this photograph was taken in 1885 (a rare picture, since Kitchener's two pet hates were public dinners and being photographed) was a Major in the Egyptian Army. He resigned from the Egyptian Army after the death of his hero, General Gordon, but pursued a highly distinguished military career in the Sudan (for which he was awarded a barony), South Africa and India. He was recalled to London on the outbreak of the First World War to serve as war minister in Asquith's cabinet, but in 1916, *en route* for Russia in the cruiser, HMS *Hampshire*, was drowned when the ship struck a mine off the Orkneys. He is best remembered as the face and pointing finger on a British First World War recruiting poster, 'Your Country Needs You'.

In 1896, Queen Victoria described Kitchener as 'a striking, energetic-looking man, with a rather firm expression, but very pleasing to talk to'. Others, including Lord Curzon, Viceroy of India, and his war cabinet colleagues, found him far from pleasing – but there was no denying the impact his visage had on most people. Winston Churchill wrote that 'The heavy moustaches, the queer rolling look of the eyes, the sunburnt and almost purple cheeks and jowl made a vivid manifestation upon the nerves'. His biographer, Philip Magnus, expands on the importance of the famous Kitchener moustache:

> His appearance was extremely impressive, and his moustache was justly celebrated not only throughout the Army, but throughout the Empire. Its length and bushiness were unique, and it would be easy, but wrong, to dismiss it with a smile. It was the ideal of all moustaches of all drill sergeants throughout all the armies of Europe; and in that exaggerated form it became a symbol of national virility. It appealed to the martial instinct of the British race at a time when the nation had been demilitarized materially and spiritually, to an extent which can rarely have been paralleled.

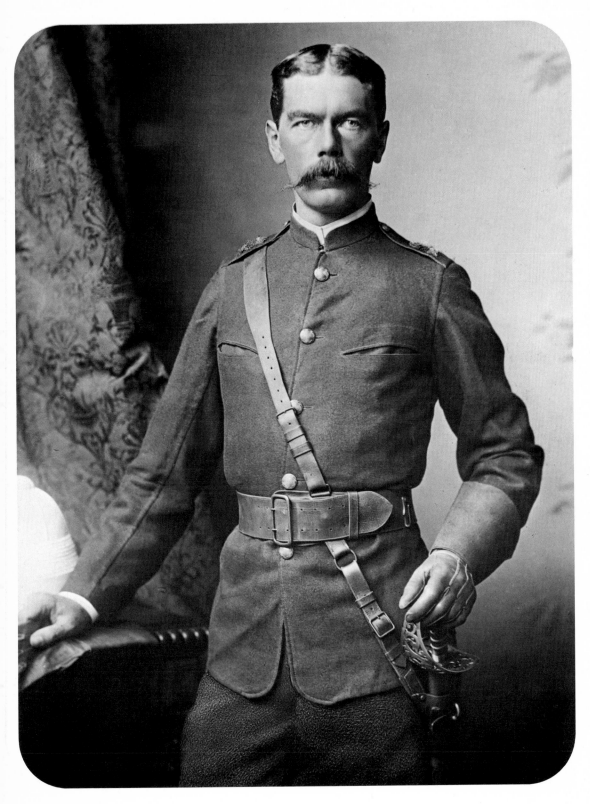

Captain Matthew Webb
1848 – 1883

At 1.04 pm on 24th August 1875, Captain Matthew Webb, a master mariner, began his second attempt to swim the English Channel. He was already a national hero; his stamina and powers of endurance were legendary. During his childhood in Shropshire he had saved one of his brothers from drowning in the River Severn. He joined a Liverpool training ship when he was 12, and helped to rescue a ship-mate from the River Mersey. While an officer aboard the Cunarder, *Russia*, he tried single-handedly to rescue a sailor who had fallen overboard during a storm in the Atlantic, and for this he was awarded the Royal Humane Society's first gold medal.

In 1873 Johnson, one of the great Victorian swimmers, had failed to swim the Channel. Two years later, Webb gave up command of his ship to train for his own attempt. He dieted on fat meat, two salads and three pints of good beer a day and during his training set a record for long-distance swimming, unbroken for 24 years, of 21 miles in 4 hours 45 minutes with the Thames tide from Blackwell, in Oxfordshire, to Gravesend, Kent. On his first cross-Channel attempt he was swept ten miles off course by strong tides, and gave up after seven hours in the water.

Conditions for his second try were more promising. His skin gleaming with porpoise oil against the cold, he set off amid cheers from a crowd of about 500 spectators gathered on the Dover shore. He was piloted by an experienced boat-man and accompanied, at his own request, by journalists from *Land and Water* and *The Field* magazines, acting as referees. At intervals during his swim he was refreshed with beer, brandy, beef tea, coffee and cod liver oil.

At about nine in the evening he was stung by a jellyfish and complained of feeling 'deadly sick', but revived after a tot of brandy. By 10.20 he was 14 miles off Dover, swimming strongly and in capital spirits. 'The phosphorescent state of the sea,' reported *The Times'* Dover Correspondent the following day, 'occasionally surrounded him with a sort of halo.'

At 10.41 pm on the 25th he touched the Calais beach after nearly 22 hours of swimming. His long, clean breast stroke had carried him through a total of $39\frac{1}{2}$ miles of sea and he had fought his way through three tides. His achievement was not matched for another 36 years and not beaten for 59.

His success brought fame, but only temporary fortune. In order to make a living he became a professional stunt man, giving exhibitions of diving and swimming and demonstrating his powers of endurance in England and in the United States. He lent his name to advertisements, and his portrait appeared on matchbox labels for years.

By 1883 his epic feats were beginning to take their toll. He was tiring, and reported to be spitting blood, and yet, against the advice of his doctor brothers he attempted to swim across the rapids just above the Niagara Falls. Crowds watched as he struggled for eight minutes only to disappear below the surface of the water. He was never seen alive again.

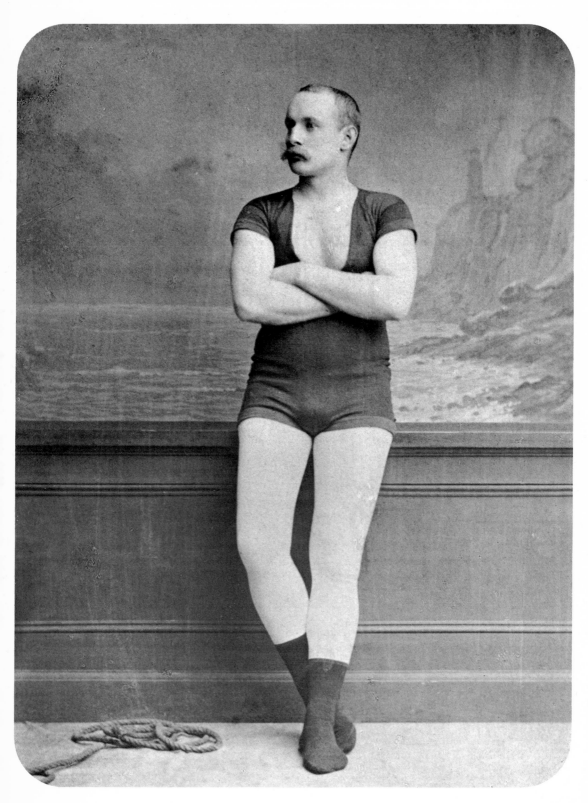

Index

Figures in **bold** type refer to full-page plates.